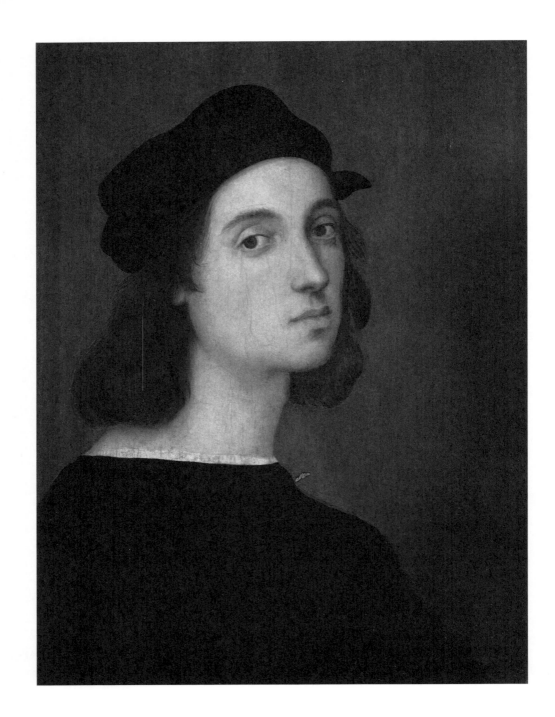

VINCENZO FARINELLA

RAPHAEL

The author would like to thank
Giovanni Agosti, Giorgio Bacci,
Andrea Baldinotti, Roberto Bartalini,
Francesco Caglioti, Antonio Pinelli
and Linda Pisani.

PAGE 2

Self-portrait, ca. 1506, Florence, Galleria degli Uffizi, inv. 1890.

EDITORIAL COORDINATOR
Paola Gallerani

TRANSLATION
Susan Wise

EDITING
Andrew Ellis

ICONOGRAPHIC RESEARCH
Alessandra Montini

CONSULTANT ART DIRECTOR
Orna Frommer-Dawson

GRAPHIC DESIGN
John and Orna Designs, London

LAYOUT
Cromographic, Milan

COLOUR SEPARATION
Cross Media Network, Milan

PRINTED NOVEMBER 2004
by Conti Tipocolor, Calenzano (Florence)

© 2004 – 5 Continents Editions, Milan
info@5continentseditions.com
ISBN 88-7439-121-8

PRINTED IN ITALY

CONTENTS

INTRODUCTION: "RAPHAEL IS A DIFFICULT PAINTER"

The winter of 1944 was one of the most dramatic in the history of Italy. The country was destroyed, its cities, its monuments and its soul were broken. It was at this time that Arturo Martini, ever more discouraged and pessimistic, decided to vent his thoughts about sculpture, art and life in a series of conversations with his journalist friend Gino Scarpa: an extraordinary document for the idiosyncrasies and still-unappeased passion stirring behind the words, occasionally disconnected, often so urgent that they forced the great sculptor to resort to the Venetian dialect. In these pages, where the true figurative models are to be sought in the most archaic, primitive expressions closest to nature, Raphael is the perfect example of that absolute, unattainable "classicism" which no longer appeals to twentieth-century artists. The precocious genius without a place in history, like Mozart, the artist who appears out of the blue, without real roots:

"Raphael: a bulb… in a basin of water. But I need more time. He's like Mozart. The two of them are marvellous but monstrous […] and then vanishing from history like Raphael."

So the painter becomes the example of the "Greek" genius that cannot appeal to the "Latin" soul of an Italian artist:

"There is nothing Latin about Raphael, [he is a] negation of us. Exemplary like Mozart, with no roots in music. Beauty. In Italy beauty does not exist, here we have drama. This fosters in us incomprehension and dislike […]. We do not know how to deal with it. The only example in Italy. Flowers that sprout in Greece and fall in Italy. Coming from above, whereas in Italy everything comes from below."

In 1965 Renato Guttuso, reflecting bitterly on "the crisis in the values of our civilisation", wondered how "a painter so wonderfully natural, elevated and human in balance, so classically earthly and Italian, so communicative as Raphael, can seem almost incomprehensible to many":

"Raphael is a difficult painter. Just the simple fact that he appears so clear, so limpid, so "popular" seems to be a trap, makes us suspicious. […] It is especially difficult to talk about him in our day, in an anti-Renaissance, anti-Humanism era in which the collective spirit at odds with the values civilisation developed seems not to feel the need to renew and refresh them, but to abuse them."

André Chastel, recalling in 1983 the "over-vaunted Madonnas and over-famous, over-commented compositions of the Vatican and the Farnesina", singled out an authentic "anti-Raphaelism" in modern culture that had arisen at the end of the nineteenth century and become a near commonplace in the twentieth. The difficulty of Raphael for contemporary taste is a fact we must keep in mind if we wish to endeavour to approach his painting in a new, unprejudiced spirit.

In 1940 in the *Ampliamenti nell'Officina ferrarese*, Roberto Longhi pondered over the meaning, for the early sixteenth-century Emilian painters, of Raphael's classicism (that "full, fused, in a nutshell Lysippean expression, proposed by Rome") blasting over the plain of the Po River. He wrote a capital, illuminating page from which still today we can set off to grasp the deep sense of Raphael's merely apparently transparent language:

"After all just what did those of the "Po Valley", or to limit the field, the Emilians, make of the artistic ideas created in Rome during the supreme decade between 1510 and 1520 by Raphael and his likes? Just what, of that deeply thought-out emulsion first of the various Italian vernaculars, then between Latin-ness and Italian-ness, history and nature, that to the simple-minded sometimes seems a facile arrangement and instead is a pinnacle of taste and genius compared to which the Florentines lose their universality and go back to being provincial like Andrea del Sarto or, by a dramatic salvation, like Michelangelo, have to pounce on the argument of titanism, of the world conceived as "torso"? Just what, of that elaborate ease, of that method we might call Leopardian of handling the form prefigured by the times, the illustrious language, so that art seems hidden and contained in historical intelligence and henceforth seems but a natural dignity of customs, a way of life calmly ruling circumstances? It was not just a question of understanding the *Foligno* or the *Sistine Madonna*, the *Madonna of the Fish* or the *St Cecilia*, or the *Impannata*, but the *Acts of the Apostles*, the *Sermon in Athens*, above all the *Pasce oves meas*: the greatest discourse ever held in our painting, oratory turned into poetry. It meant even understanding the ideas, however mangled by the executors who plead like anguished souls, of the *Holy Family of François I*, the *Madonna of the Pearl* and, precisely this, the *Visitation* and the *Transfiguration*: deeply participating rhythmic unity embracing as in a royal mantle all subservient nature; melodic development that becomes harmonic rhythm, choral consonance of man with things, of feeling with intellect."

Just what, I was saying, did the Emilians understand when the vedettes of these ideas of mental perfection reached via Emilia in the 1520s: at Piacenza the *Madonna of St Sixtus*, at Bologna the *St Cecilia* in San Giovanni in Monte, the *Vision of Ezekiel* in Casa Hercolani, the *Madonna of Divine Love* in Casa Pio da Carpi?

6 APRIL 1483 – 10 DECEMBER 1500: "RAPHAELEM EIUS FILIUM LEGIPTIMUM ET NATURALEM"

In an overall re-evaluation of Raphael's pictorial work, the first problem to arise is certainly that of the paternal inheritance: to what degree did Giovanni Santi weigh on the cultural formation of his young son? Probably the most balanced solution, that neither overestimates the importance of his father, who died in August 1494 when Raphael, born in the spring of 1483, was only eleven, nor underestimates it, is to assume a determining intellectual stimulus rather than a concrete example in the practice of art. Giovanni Santi could indeed provide an extremely unusual model in fifteenth-century society, that of a knowingly cultured painter, possessing remarkable literary ambitions as a dramatist as well as an authentic vernacular poet. Aside from the theatrical representations in which he performed in 1474 and 1488 at the court of Urbino, his major work is the endless poem in terza rima *La Vita e le gesta di Federico da Montefeltro duca di Urbino*, written in the 1480s concurrently with his prestigious pictorial work in the Palazzo Ducale (the beginning of the decoration of the Cappella delle Muse). It fully reveals the breadth of his culture, not merely figurative, as well as to what degree this original artist-man of letters could influence the mind, doubtless already very curious, of Raphael as a child. It would be difficult to overestimate the impression the verses of the *Disputa de la Pictura* must have had on Raphael. In the poem dedicated to the dukes of Urbino his father, in a text probably conserved in manuscript in the workshop after his death, had drawn up an extraordinary tour of the fifteenth-century figurative scene (listing at least thirty-eight painters and sculptors). In this vast survey of a polycentric, polyphonic artistic Italy where the great early fifteenth-century masters (Masaccio and Fra Angelico, Gentile and Pisanello) dialogue as equals with the Flemish patriarchs (Van Eyck and Van der Weyden), the scope of information is simply amazing, the result of often first-hand knowledge, matured through travels and acquaintances in many regions of Italy (of the main centres only Naples and Milan are missing), and at the same time the sharpness of the judgements. The hierarchy of values culminates with Mantegna, the perfect example of the courtier-artist who, by his insuperable skill in perspective and Antiquity, "rules supreme". We even wonder if it might not have been Raphael himself who took his father's precious codex to Rome (now in the Vatican Library), a tribute to a literary text that had played a vital role in his cultural formation. Furthermore I think we

ought to look into another possible important homage to Giovanni Santi, gone prematurely but doubtless still alive as an intellectual model in his son's memory: identifying as his portrait, rather than Sodoma, Perugino or Pinturicchio as still often claimed, the face of a middle-aged man, friendly and smiling, that as in an ideal passing the baton is placed above the famous self-portrait of Raphael in the *School of Athens*. There figurative artists, finally freed of the drawback of craftsmanship, merged with the greatest thinkers of Antiquity. The existence of a miniature portrait of Giovanni Santi executed by Raphael in 1507 and owned in 1520 by the banker Bindo Altoviti is attested in the fifteenth century although today the work is lost. Furthermore on 4 October 1511 in an important document where Pope Julius II appoints Raphael "scriptor brevium apostolicorum" to provide him with a significant income, the artist is still defined as "Johannes de Urbino scolari", reiterating his essential bond, not merely sentimental but cultural, with his painter and writer father.

pl. 19

The second fundamental problem in a reconstruction of Raphael's earliest activity is that of his artistic training. Should we believe Vasari who in the mid-sixteenth century claimed Perugino was the only answer, imagining the Urbino youth developing in the richest, most cosmopolitan pictorial *bottega* in central Italy? Or else give some credit to the scholars who rejected Vasari's critical construction, drawing a more varied and contradictory trajectory, as if Raphael, slowly maturing in his father's workshop left in the hands of a small-timer like Evangelista Pian di Meleto, could have encountered not only Perugino but other protagonists of painting in central Italy in the last decade of the fifteenth century as well? Unfortunately the documented information is not a great help. Except for the old inheritance dispute with his stepmother in Urbino, we know nothing certain about Raphael's life in the years between July 1494, when he was appointed residuary legatee with his uncle Bartomoleo in Giovanni Santi's will, until 10 December 1500 when, aged seventeen but already "magister", he signed the contract, together with Evangelista Pian di Meleto, for the altarpiece dedicated to St Nicholas of Tolentino for a church in Città di Castello [fig. 1]. Neither is it clear whether Vasari's edifying tale – where a loving father, recognising his own smallness compared to his son's genius, decides to entrust him to a great master – is based on older sources or is not instead a tale triggered by the stylistic interpretation of Raphael's first Umbrian works. In Lorenzo Torrentino's 1550 edition the Arezzo historian even interpreted the Oddi altarpiece in the Perugian church of San Francesco as a work of collaboration between the two artists ("and you could not make out which was his work and which was Pietro's"). In 1568 the error was rectified but Vasari continued to insist on the extraordinary mimetic skill of the young Raphael with respect to Perugino's works, arguing, for instance, for the Gavari *Crucifixion* in the church of San Domenico at Città di Castello that "if his name were not written on it nobody would believe it was a work by Raphael but indeed by Pietro". Obviously in his opinion only

pl. 4

pl. 3

a long period of apprenticeship in Perugino's workshop could help explain this astonishing similarity of manner.

But it was probably a very different story, as we gather from the first known works by Raphael where Perugino's teaching does not appear to be as exclusive as we might expect from a 'creature' of his *bottega* (instead, proximity with Perugino's models, after a few experiences of a different nature, seems to have gradually increased over the years, climaxing in several works executed toward 1503–4). And we also have an indirect but valuable testimonial of Raphael's very first laboratory in the so-called *Libretto veneziano di Raffaello*: a sketchbook of drawings conceived as an authentic book of models in which in the early sixteenth century an artist close to Raphael arranged and replicated in a fair copy a series of graphic annotations amassed by the Urbino youth during his years of

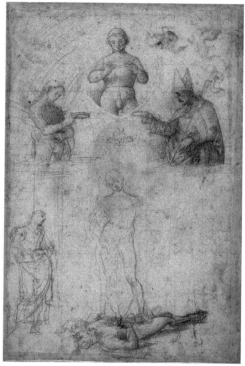

Fig. 1. Raphael, *Compositional study for the Coronation of St Nicholas of Tolentino*, Lille, Palais des Beaux-Arts, inv. 474 r.

study and travels and that contributes to outline a sort of prehistory of the artist's cultural background [fig. 2]. Raphael's formation in light of this evidence appears amazingly broad and reveals an unprejudiced eye, comparable to that documented in his father's verses, on the most modern aspects of painting in central Italy. Along with the solutions of Perugino, doubtless the most admired artist with his proto-classical rhythms (not just the Umbrian and Tuscan Perugino of the Sacred Conversations but also the Roman Perugino, great frescoist of the Sistine Chapel), there are the new inventions *a grottesca* of Pinturicchio, tireless narrator of fantastic and imaginary tales, the sharp anatomical investigations of Pollaiuolo and Signorelli, the drama of Mantegna petrified in the black and white of engravings, without overlooking a moderate interest in the obsessive realism of the northerners and a first shy glance at Leonardo's psychological intricacies. But in this *Libretto veneziano* there are also the places where the adolescent artist took his first steps. Perugia, but especially Urbino, the "city in the form of a palace" [fig. 2], where it was as if the whole history of culture had assembled in the *Uomini illustri* portrayed in Federico da Montefeltro's *Studiolo* to celebrate an exceptional patron. And fascination for classical art is present at an early

stage, maybe even before seeing Rome, ranging from the anatomical asperities of the red *Marsyas*, an antique sculpture in the Medici collections, to the carnal tenderness of the *Three Graces* removed to Siena in 1502.

Such a completely non-linear course may explain the results of Raphael's first Umbrian works, receptive to different, albeit contradictory, experiments: without the exclusive tutelage of a great and cumbersome master, but ruled by an omnivorous intellectual curiosity and the ability, already evident at this time, to assimilate everything without apparent traumas and even with extraordinary ease.

IO DECEMBER 1500 — OCTOBER(?)1504: "MIRA DOCILIS INGENII SUAVITATE ATQUE SOLERTIA"

Young Raphael's intellectual openness, already underscored by Paolo Giovio when in the mid-1520s he began the *Life of Raphael da Urbino* grasping the "wonderful sweetness and readiness of a ductile talent", is obvious if we examine what survives of his first documented commission, the altarpiece dedicated to St Nicholas of Tolentino for Città di Castello. Here the seventeen-year old *magister* was assisted by his father's old collaborator Evangelista Pian di Meleto, to whom have been attributed the qualitatively less convincing parts of a work certainly entirely conceived, as the preparatory drawings [fig. 1] prove, and for a large part carried out personally, by Raphael. It must have been an impressive altarpiece, an extremely important opportunity to earn recognition and show the degree of his cultural updating. Indeed the fragments conserved do not fail expectations. The Louvre angel, with the marked rotation of the face, shows how Perugino's sweetness could be empowered by heeding the anatomical experiments of Signorelli, who had moved to Orvieto in 1499 but in the years before left significant proofs of his modernity and substantial differences with respect to Perugino, precisely at Città di Castello. The monochrome frieze of candelabra which enclosed the architectural space with the coronation of the Augustinian saint undoubtedly suggests a tribute to the decorative alternatives *all'antica* that at Urbino had brought success to the Milanese sculptor Ambrogio Barocci, another old friend of Giovanni Santi; yet at the same time they seem updated to the new decorative manner inspired by classical Roman painting that Bernardino Pinturicchio had essentially popularised in a number of frescoed cycles (his name pl. 1 seems to appear again for the Brescia angel, in which Perugino's impassive gentleness seems enlivened by a fresher psychological insight).

Indeed there is a painting, lovely even in its ingenuousness, that very clearly recalls pl. 2 Pinturicchio, the *Resurrection of Christ* of the museum in São Paulo. The small panel

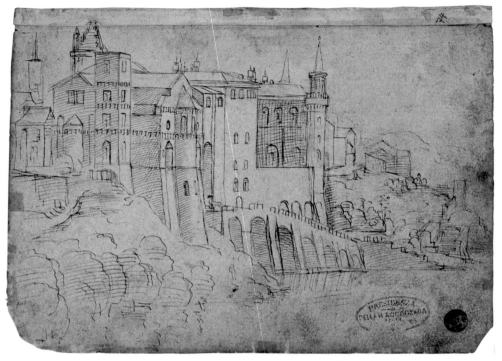

Fig. 2. Anonymous Umbrian draughtsman close to Raphael,
Veduta of Urbino, Venice, Gallerie dell'Accademia, *Libretto di Raffaello*, fol. 39v.

failed to convince of its authenticity those critics who, just like Vasari, saw Raphael as exclusively a 'creature' of Perugino and could therefore not accept such a distinct stylistic divergence at the dawn of the Urbino artist's career. As a matter of fact, the existence of three autograph preparatory drawings by Raphael for this work make any other hypothesis unlikely. The *Resurrection* becomes essential for understanding that in the first years of the century Raphael felt the need to go and seek out in Pinturicchio's ornamental repertory a decorative enrichment to flaw Perugino's serene harmonies. This explains the splendid polychrome marble sarcophagus, as precious as a reliquary, or the fantastic armours of the Roman soldiers, dismayed yet thoroughly elegant in their clothes in which a brilliant stylist reinvented imaginary archaeological garb.

Besides, ties between Pinturicchio and Raphael are documented with the utmost certainty. On 29 June 1502 Pinturicchio received from cardinal Francesco Todeschini Piccolomini (Pope Pius III in September–October 1503) the prestigious commission to decorate the Piccolomini Library in the Duomo of Siena. Not feeling strong enough to invent a cycle of scenes without a previous iconography (and perhaps as well because of serious health problems that in September of that year induced him to draw

up his will in Perugia), he decided to call upon the Urbino youth to provide him with drawings, complete with composition and perspective, that could figuratively express the principal episodes of the life of Enea Silvio Piccolomini (Pope Pius II from 1458 to 1464). Such an uncommon relationship, in which a mature established master asks a nineteen-year old artist practically at his debut to help him, must have been grounded on a previous acquaintance. Several of Raphael's drawings, in fact preparatory for Pinturicchio's Sienese stories, offer valuable confirmation: a sheet in the Uffizi [fig. 3], where a few ideas for the figures in the foreground of the *Departure of Enea Silvio Piccolomini for the Council of Basle* were jotted down, provides the reasons for Pinturicchio's apparently surprising decision. As a matter of fact at this time, meaning toward 1502–3, young Raphael's modernism must have seemed stupefying to eyes accustomed to the old fifteenth-century manner: the horses, as huge as the antique giants of Montecavallo in Rome, with the riders whirling in space with utter freedom, betray a daring dialogue with the subtlest Leonardesque notions in works the master left in Florence, such as the *Adoration of the Magi*, supremely in vogue since Leonardo's return from Milan.

The year 1503 is a crucial one in young Raphael's career. It is probably the year of his early stay in Rome and first direct encounter with those classical ruins that for the Urbino artist would become an example and an obsession. Toward that same 1503 two works were devised that represent the most obvious, earnest homage from Raphael to pl. 3 Perugino's painting. The Gavari *Crucifixion* distils the Umbrian master's models (notably the *Crucifixion and Saints* for San Francesco at Monteripido, under way in Perugino's workshop toward 1502–3) to a level verging on technical and stylistic perfection. The nude Christ alone, with its insistent anatomical investigation, echoes Signorelli's experiments. But subsequent to the first years in which Raphael sought to broaden his experience, the entire work appears an exclusive, open tribute to pl. 4 Perugino's unassailable genius. The Oddi altarpiece on the other hand shows that even this height of passion for Perugino soon grew more complicated, in Raphael's dynamic mind, almost as though the urge to constantly experiment new solutions drove him to overcome his own results even in works not yet completed. The stylistic hiatus between the upper section where the coronation of the Virgin reinstates Perugino's models but even those of his father Giovanni Santi and the lower section with the overwrought apostles surrounding the sarcophagus daringly shown from an angle was explained hypothetically by a protracted execution leading to the completion of the work in 1504, at a time when confrontation with Florentine innovations became more and more pressing for Raphael.

The dialogue with Perugino climaxed at the same time it ended with a painting dated pl. 5 1504, the *Marriage of the Virgin*, that has a paradigmatic value as well by the signature

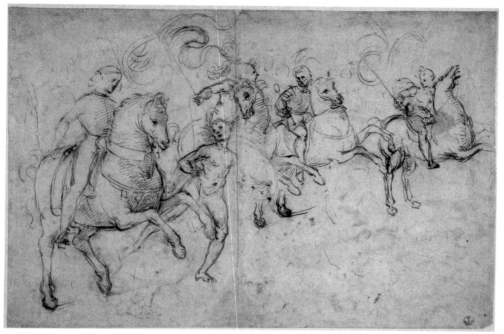

Fig. 3. Raphael, *Four Horsemen and a Male Nude moving to the right*, study for one of the frescoes by Pinturicchio in the Libreria Piccolomini (*The Departure of Enea Silvio Piccolomini for the Council of Basle, winter 1432*), Florence, Galleria degli Uffizi, Gabinetto Disegni e Stampe, inv. 537 E.

placed in great evidence like a proud demonstration of self-awareness: a sign that the twenty-one year-old painter at the eve of a radical change of his cultural horizon realised he had reached a key moment in his artistic career, while fully taking stock of his Urbino roots. In this case comparison with two of Perugino's famous compositions, the Sistine Chapel *Christ's Charge to Peter* and the Caen *Marriage of the Virgin*, shows that Raphael no longer intends to pay tribute to the artist whom he had most admired in his adolescence but to challenge him on his own ground, using one of his works as a model, ridding it of its fifteenth-century 'flaws' and turning it into a spacious, absorbing modern scene.

Two small paintings doubtless executed in 1504 as well, aside from being the first in the field of profane themes that would become increasingly relevant during the Roman years, illustrate the vastness of the repertory of sources Raphael's painting is based on. The *Vision of a Knight* and the *Three Graces* were probably the two wings of a diptych. pls. 6, 7 We have no certain information about the patronage of such a precious, subtle, intellectual work. The subject, as alas only too frequently in Raphael's mythological works, lent itself to an excess of interpretations. Actually the influence of a late-fifteenth-century northern woodcut representing *Hercules' Choice* at a crossroads of

Virtue and Vice seems sufficient evidence for interpreting the so-called *Vision of a Knight*, while the three nude female figures holding out golden apples, although derived from a famous antique sculpture group representing the *Graces*, in all likelihood were the mythical Hesperides offering Hercules, after his victorious choice, the fruit of immortality. So, if we accept this simple and even obvious interpretation, the work is extremely sophisticated, calling upon sources as antithetical as a coarse German engraving and the seductive antique sculpture group that appeared in Siena just a few years before (including, for the 'moralised' landscape of the *Vision*, the exact borrowing from the one in Botticelli's Cestello *Annunciation*). The painting was certainly conceived for an erudite patron who must have been familiar with Prodicus' moral tale conveyed by several literary sources (including Xenophon) and that could be identified as the Greek hero engaged in a process of purification, a 'knight' bearing arms crafted for him by Hephaestus (according to the pseudo-Hesiodic *Shield of Hercules*). Stylistically the two panels are striking by the softer pictorial material, increasingly fluid and bright, with effects of tangible smoothness in the flesh of the female nudes that appear to thrill as though actually wrapped in a veil of air warmed by the flush of the skin. In this work, comparison with Florence and especially with the notions of Leonardo and Fra Bartomoleo was more insistent than ever, soon forcing Raphael to move to the place that could still be considered the launching pad of Italian art.

AUTUMN(?) 1504 – AUTUMN 1508: "AT THIS TIME THE PAINTER RAPHAEL OF URBINO CAME TO FLORENCE TO STUDY ART"

The well-known letter Giovanna Feltria Della Rovere sent on 1 October 1504 to Pier Soderini, gonfalonier of Florence, recommending "Raphael painter of Urbino [...] a sensible and well-mannered youth" in order that a period of study in the lively Tuscan centre enable him to attain to "a good perfection", is doubtless an eighteenth-century fake. Yet the words of Fra Bartomoleo's biographer ("at this time the painter Raphael of Urbino came to Florence to study art") confirm the painter's intention to undertake a new period of apprenticeship in Florence, even after recent works executed in Umbria had imposed him as an authentic leader.

Two works carried out toward 1505 at Perugia during the artist's periodic returns to Umbria indicate the beginning of this direct dialogue with Florentine innovations. The Ansidei altarpiece, probably begun the year before, still seems guided by the desire to perfect, from within, Perugino's language we had already pointed out in the *Marriage of the Virgin*. Notwithstanding, the renewal under way can be detected in the spatial simplification of the composition set in an absolutely rigorous architecture, but for this very reason all the more monumental and attuned to the protagonists' psychological

pl. 8

pl. 5

impulses: a first influence of Leonardo has aptly been observed here. The San Severo pl. 9
fresco reveals on the other hand the impact of Raphael's first very intense visual
emotion in front of the fresco with the *Last Judgement* that Fra Bartomoleo, with
Mariotto Albertinelli, had executed for the Ospedale di Santa Maria Nuova: a very
early work (1499–1501) and essential for the launching in Florence of the new "modern
manner" that was soon to lead to Leonardo's and Michelangelo's dazzling essays.
Indeed the friar painter was to be the first link between Raphael and Florentine
circles, as we see in several figures of the only surviving section of the Ansidei
altarpiece predella.

For Raphael, direct confrontation with Leonardo's Florentine works was soon to
become determining. The portrait of the *Lady with the Unicorn*, a young bride showing pl. 12
her principal virtue, chastity, in the symbolical little animal tenderly held in her arms
(replacing the original pet dog, emblem of conjugal faith), is a demonstration of
Raphael's truly extraordinary capacity to tackle even the most difficult, enigmatic
texts, such as Leonardo's ineffable *Mona Lisa*, just begun and certainly not yet
completed, and to translate them in a transparent, accessible language. The mysterious
psychology of Monna Lisa Gherardini, wife of Francesco del Giocondo, was first
shown, as in the *Lady with the Unicorn*, in front of a columned portico opening onto a
prehistoric landscape where traces of man seem devoured by an enveloping nature in
constant mutation. Under the Urbino artist's brush it becomes the springlike image of
an amiable lady of the prosperous Florentine bourgeoisie placed in front of a
resplendent view of the Tuscan countryside. And to quote Roberto Longhi, who can
be considered the true discoverer of the virtues of this lady, what is striking is all "the
grace of reserve, bearing, expression that is inimitable in Raphael's portraits in
Florence".

In the Doni husband and wife pair, the distance from the Leonardesque prototype that pls. 10, 11
was nonetheless a determining model for all of Raphael's portraits becomes more
apparent. Agnolo, the rich draper, collector and art lover, stares at the onlooker with
disconcerting frankness, taking up most of the space with the rotation of his shoulders
and his left arm resting on a baluster. Maddalena, although still very young, eschews
any temptation to idealisation and conceals her psychology under the elegance of her
garb and the splendour of her jewellery that, like a ciphered message, contain subtle
allusions to the feminine virtues of purity and chastity. Under the scrutiny of an eye
mindful of the lenticular limpidity of Netherlandish painting (notably Memling's
portraits, so appreciated in Florence), the middle-class couple, self-assured and master
of its destiny, wishes to favour and at once glorify its future descent by the
mythological references contained in the verses (by an anonymous Florentine artist
who collaborated with Raphael), choosing to be portrayed by the painter in front of

a gentle luminous landscape, remote from Leonardo's mists and vapours, a gentle breeze barely ruffling their hair.

During his years in Florence Raphael, lacking major public commissions, insistently goes back to the theme of the Madonna and Child, well-suited for private patronage, gradually developing more articulated, monumental forms. The so-called *Belle* pl. 15 *Jardinière* (the eighteenth-century name is especially fortunate, its sweet everyday quality having insured the huge popularity of works like this one, where the Madonna could be seen as a "Peasant Virgin") represents, probably in 1508, the success of the attempt pursued in the years before in a series of insistent experiments to contrive a composition that, keeping in mind the models offered by Leonardo (the cartoon of *St Anne*) and Michelangelo (the Bruges *Madonna*, the Pitti and Taddei tondos), would achieve a total harmony where the figures seem to spontaneously define a perfect pyramidal geometry. Yet a design that does not freeze the scene in a rigid decorum but allows the holy protagonists to behave with utter naturalness, caught in spontaneous gestures expressing more human feelings, in a landscape enveloping the figures like a pl. 14 welcoming bosom. The Canigiani *Holy Family* enriches these experiments, complicating the composition yet still placed in an absolutely geometric structure, by a greater insistence on the five protagonists' psychological reactions. While two children are tenderly playing with the Baptist's cartouche (where we make out the words – "ECCE AGNUS DEI" – referring to Christ's future Passion) under the unknowing eye of the Virgin, who has just stopped reading, the anxious gaze of St Elizabeth meets that of St Joseph leaning wearily on his staff. Even the landscape background betrays new ambitions, in the two northern cities placed like an earthly counterpoint to the cherubs in Heaven playfully peeping out of the clouds. Once again Raphael's ambition in these crucial Florentine years is not merely to "learn" the "modern manner", appearing in the overwhelming figurative texts of Fra Bartomoleo, Leonardo and Michelangelo, but to translate these inaccessible formal inventions into more human, down-to-earth images, as in a re-evocation of Luca della Robbia's classical transparency, to mellow a formal research that seemed accessible to but a very few minds into a harmonic, universal idiom.

This all-out *paragone* with the revolutionary Florentine innovations of the early sixteenth century culminates in an ambitious work Raphael did for an Umbrian patron: the altarpiece Atalante Baglioni wished for the funerary chapel in the church pl. 13 of San Francesco al Prato in Perugia, signed and dated by the Urbino artist in 1507. In this instance the many conserved preparatory drawings allow to follow from within the genesis and evolution of Raphael's invention. We grasp the complex process of self-criticism and gradual perfecting leading the artist to the elaboration of such apparently spontaneous, immediate effects. The alterations are not only a gradual formal

improvement of the image by selecting the most efficient composition and most expressive movements, but also significant iconographic changes that touch on the deep meaning of the work.

In the case of the Baglioni altarpiece Raphael had first planned a far more static contemplative scene devoted to the theme of the *Lamentation over the Body of Christ* lying on the bare ground after the deposition from the Cross, once again inspired by a painting by Perugino (the *Lamentation over the Dead Christ* of 1495 for the Florentine convent of Santa Chiara, presently at the Galleria Palatina, particularly appreciated for the expressivity of the movements and faces). But the drawings reveal a sudden change in the design, undoubtedly in agreement with the patronage, and the wish to create a far more declamatory, striking image, lifting Christ's body and having it carried toward the sepulchre (the rocky cave yawning on the left edge of the panel) by a mournful procession filing dynamically before our eyes. In this instance a number of visual sources have been mentioned that might have inspired Raphael's highly receptive imagination (including Mantegna's print with the *Deposition*, studied in the *Libretto veneziano*, and a Roman sarcophagus with the entombment of the body of Meleager, explicitly praised by Alberti's *De Pictura*, a detail of a Signorelli fresco at Orvieto where the canonical scene of the *Lamentation* is precisely accompanied by the far less diffused one of the *Entombment*). Raphael was probably familiar with all these stimuli and kept them in mind, while recasting them with his usual power of assimilation. The finished work shows that his real ambition, at the time, faced with an invention so rich in dramatic potentials, was to compete with the work of Michelangelo that at the time in Florence probably caused the real sensation. The almost wild anatomical heroism of the *David* (in the figure of the youth in profile carrying Christ's body), a sculpture that had often challenged Raphael during those Florence years, the grieving elegy of the Vatican *Pietà* (in the contemplative abandon of the Redeemer's dead body), the serpentine winding of the figures of the *Tondo Doni* (in the rotating motion of the Holy Woman who turns to sustain fainting Mary) are all obvious quotations from Michelangelo. They betray Raphael's desire to vie with the Florentine artist who, in the cartoon of the *Battle of Cascina*, invented a new way to tell a dramatic story without narrative digressions, entirely expressed and you might say embodied in the articulation of the human figure.

The first important public commission Raphael gained in Florence, known as the *Madonna del Baldacchino* designed for the Dei chapel in Brunelleschi's Santo Spirito pl. 16 church, was never completed. In the fall of 1508 the artist was called by Pope Julius II to Rome, a city that at that time was becoming the new launching pad of Italian art, permanently replacing Florence. However, even unfinished this monumental altarpiece, in which the dialogue with Fra Bartomoleo's austere but utterly modern

compositions culminates, was to provide a model *sacra conversazione* for Tuscan artists for decades. Raphael's ambitions are particularly apparent in the architectural background, fashioned on the form of a niche of the Pantheon, and in another detail from Antiquity: the arms of the throne of the Virgin drawn from a famous Roman sculpture, the Ciampolini *Jupiter*. The result allows us to directly grasp the artist's huge expressive enrichment in the years spent in Florence: the symmetry of the composition and the equilibrium of the poses becomes warmer and is enlivened in the human veracity of the gestures and psychological reactions in a series of absolutely natural sacred dialogues that deeply involve the beholder's eye and heart.

AUTUMN 1508 – 1 AUGUST 1514: "AD PRAESCRIPTUM IULII PONTIFICIS"

We should date to the fall of 1508 the arrival of Raphael on the labyrinthine yard of the Vatican Palaces. A team of painters was already at work decorating the rooms that Pope Julius II had chosen for his private apartment, he no longer wishing to live in those rooms that, thanks to Pinturicchio, glorified the family of Pope Alexander VI Borgia. The artist was still in Florence in July 1508 as we know by a very recently discovered document that attests to the execution, by a "Raffaello di Giovanni dipintor" that it seems likely we can identify as Raffaello Sanzio, of a "Nostra Donna per l'Udientia de' Nove" (Our Lady for the Udientia de' Nove), that is, a prestigious *Madonna and Child* for the Sala dell'Udienza dei Signori in the Palazzo Vecchio. Then on 13 January of the following year appears the first payment for a fresco executed in the Stanza della Segnatura, in all probability the *Disputation over the Most Holy*
pl. 18 *Sacrament*. When Raphael first set foot in the room that was to witness his greatest accomplishment in monumental decoration, Antonio Bazzi was already at work on the
pl. 17 scaffolding erected for the decoration of the vault. The Vercelli painter had precociously proved himself in Sienese circles and been in the good graces of the pontiff Della Rovere owing to the protection of the Chigi. Compared to the frescoes executed by Sodoma, updated to the notions of perspective that had blossomed in northern Italy (the trompe-l'oeil oculus with the cupids open onto the sky tells us he was familiar with the experiments of Mantegna, Bramantino and Zenale) and to the passion for the antique that had offered an ephemeral Roman success to an anything but excellent painter like the Bolognese Jacopo Ripanda, Raphael's first work must have appeared to his patron, but also to the humanists and artists gravitating around the papal court, like the sudden, unforeseen irruption of a new, if long-awaited language.

pl. 18 Indeed from a monumental viewpoint the *Disputation over the Most Holy Sacrament* develops those compositional experiments inspired by Fra Bartomoleo's Florentine
pl. 9 works that in 1505 had led up to the San Severo fresco in Perugia: a grandiose half-circle

of sacred figures seated upon a throne of clouds reflected on Earth by a very free apse-shape of popes and theologians placed in a structure that, although arranged in rigorous geometric sections, does not freeze but enhances the human naturalness of the protagonists. The vertical theological axis dominating the fresco, composed of God the Father, Christ, the Holy Ghost and the Host consecrated on the altar, is also the axis of symmetry for the entire composition: on the right and the left the saints and patriarchs of the upper part vie with the human figures of the lower part in assuming poses, gestures and expressions of striking naturalness. So Adam can cross his muscular legs and clasp his knee in conversing with St Peter, while the theological discussions arisen among the Christian thinkers give rise to passionate arguments that induce instinctive psychological reactions: in the countenances, familiarity with Leonardo's physiognomic experiments merges with some likely reflection on what a very original painter like Bramantino painted in another of Julius's rooms. But the entire fresco, while being dedicated to the glorification of theological thought all through the history of Christianity, unfolds like a lively narration, not excluding the most instinctive emotional reactions: like the figure of the youth on the far right who, conversing with the bearded elder in his antique-style drapery, leans over the marble baluster to stare at the Sacrament, invading the onlooker's space with an absolutely natural gesture.

Raphael immediately matured in contact with Julius's court, where you could actually touch the theme of the rebirth of the antique by studying the masterpieces of classical sculpture converging in the courtyard of the Belvedere, or examining the architectural designs, truly 'imperial' in their boundless ambition, that Bramante was tirelessly producing for the pontiff's Caesarean aspirations. It can be seen on the second wall Raphael put his hand to in the Stanza della Segnatura, probably the so-called *School of Athens*. In this case as well a thought of daunting clarity and monumentality pl. 19 – summoning the entire history of classical philosophical thought in a resonant antique hall placed under the protection of Apollo and Minerva – is expressed with a compositional skill that moves great masses of figures, always preserving the individuality of the movements and the soul not only of the main actors (the most famous Greek philosophers such as Plato, Aristotle, Socrates, Diogenes, Pythagoras, Euclid) but also the minor roles, always bursting with corporeal and psychological vitality. Suffice it to observe the anonymous figure of the youth who like a vortex of energy breaks onto the stage from the left holding a codex and a scroll, dishevelled and his cloak tossed by a sudden gust of wind. And as a second thought when the fresco was already finished, the introduction of the figure of the presumed Heraclitus, an explicit tribute to the genius of Michelangelo engaged in the titanic task of the Sistine Chapel, comes about with the utmost ease, almost as if the gap left in the foreground in the preparatory cartoon, conserved at the Pinacoteca Ambrosiana in Milan, could only be filled by that introverted, melancholy intellectual.

pl. 20 In the *Parnassus* the triumph of poetry is expressed in an unusual blending of two worlds on the slopes of Apollo's sacred mountain, under the auspices of the nine Muses, like dreamy sensual maidens lost in the contemplation of a handsome youth pls. 18, 19 playing the violin. If the *Disputation* and the *School of Athens* put the two worlds, Christian and pagan, face to face, now the groups merge as though the Golden Age were truly back on Earth. The world of poetic glory is no place for differences in culture or religion: Homer and Virgil can be Dante's companions, while even the living can converse with the great poets of the Middle Ages and Antiquity. The onlooker walking through the room is strongly called to take part personally in this intellectual utopia set on the antique Parnassus. The ardent lyric poet Sappho climbs over the windowsill, intruding in the physical space where the public moves about, while the tragic poet who matches her on the right, conversing with two companions, explicitly indicates a point at the centre of the room: the point ideally occupied by every onlooker, antique or modern, but above all from which the patron, Pope Julius II, must have proudly contemplated Raphael's fresco almost as if he alone could make this daydream come true in history.

References to the patronage are all over the decoration of the Stanza della Segnatura, including the astrological announcement of the pontificate on the vault and the name "Julius II" appearing twice on the altar of the *Disputation* where the Della Rovere stock is particularly glorified through the presence of the uncle Sixtus IV, by the tribute to the artists and humanists working for the pope in the hidden portraits of the *School of Athens* as well as by the heraldic abundance of gilded acorns and oak leaves on a blue ground. They appear more and more explicitly on the last wall, dedicated to pl. 21 the manifestation of *Justice*. A preparatory drawing by Raphael, a copy of which is held in the Louvre [fig. 4], proves the artist had first thought of decorating this wall as well pl. 20 with a single large scene as in *Parnassus*, featuring the manifestation of Divine Justice in an apocalyptic scene (God handing over the seven trumpets to the seven angels of the Apocalypse, announcing the Last Judgement): a scene that surprisingly was to put on the same plane, in front of the blinding mystical vision, the figures of St John the Evangelist and Giuliano Della Rovere. When, certainly in agreement with his patron, Raphael decided to replace that scene with other less provocative images (the *Three Virtues* in the lunette, *Tribonian presents the Pandects to Justinian* and *Gregory IX approves the Decretals* on the two walls at the sides of the window), the homage to the pontiff responsible for this new Golden Age of the arts appeared not only in the virtue of *Fortitude* holding a leafy oak branch (the heraldic emblem of the Della Rovere family) but also in the portrait of the bearded pope placed above the countenance of the medieval pope in a final transparent tribute to the patron who, behind this authentic triumph of Roman culture, appears to be the real theme of this first room of Julius II's apartment.

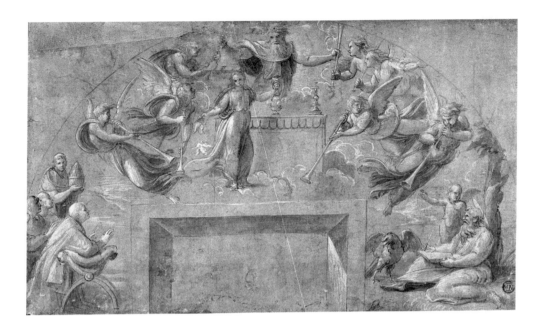

Fig. 4. Raphael (copy after?), *Apocalyptic Vision of St John*, unused preparatory study for the wall of *Justice* in the Stanza della Segnatura, Paris, Musée du Louvre, Département des Arts Graphiques, inv. 3866.

Before leaving the Stanza della Segnatura, raising our eyes toward the vault once more, pl. 17 we shall become fully aware of the epochal significance of the difference between the parts, although very beautiful, that Sodoma executed in 1508, and the monumental personifications Raphael placed in the tondos as well as the narrative episodes in the corner frames, probably toward 1510–11, at the conclusion of the decoration. A new human race bears the features of *Justice* and *Philosophy*, *Poetry*, and *Jurisprudence*, to indicate, by its huge proportions, doubtless borrowed from Michelangelo's thundering figures in the Sistine Chapel but also blending with supreme ease all the stimuli accumulated in the years in Umbria and Florence, that a new era had opened in Rome under the auspices of a patron as outstandingly energetic and ambitious as Julius II.

Surprisingly enough the pontiff's portrait that Raphael painted in the same months in which the artist was decorating the second room of the papal apartment, the so-called Stanza di Eliodoro, depicts a very different personality from the 'awesomeness' underscored by the sources, as if voided of that domineering energy that characterised him in the colossal bronze Michelangelo made a few years before for the basilica of San Petronio in Bologna. But let us not be fooled: this is not a broken man, an old man bent in body and spirit by the unfavourable events of the preceding months. Conversely, even this portrait, which in fact Julius II gave to the church of Santa Maria

del Popolo for it to be shown to the faithful during solemn celebrations, is a 'political' image that wished to convey, thanks to the painter's brilliant capacity to interpret the patron's intention, a clear ideological stance. Giuliano Della Rovere, at a difficult time of his pontificate, wants to offer a new image of his person, seized in everyday reality, seated on a high-backed chair topped by the Rovere gilt acorns in the visitors' antechamber. No longer the energetic bellicose pope who, sword in hand, had scaled in winter the walls of an enemy fortress, no longer the pope criticised for the carnal excesses of his behaviour, his quick temper that terrified ambassadors and postulants, his tremendous appetite, but a frail, human pope finally addressing spiritual values, his eye lit with an inner glow as in a moment of introspective meditation. A man who had vowed to let his beard grow, promising not to shave it until the foreign 'barbarians' were chased from Italy: a pope who, just when the king of France had called a council to depose him, seems to want to fight, at least in this 'ethical' portrait, with the weapons of the spirit and moral strength.

pl. 24 Another portrait Raphael painted in these same months is that of Tommaso "Fedra" (*Phaedra*) Inghirami, the Volterra orator and poet whom Julius appointed prefect of the Vatican Library. He may have had an active role in choosing the subjects of the frescoes Raphael was to execute in the first two rooms to satisfy the pontiff's desires of self-glorification within a structured iconographical programme. So we have the image of the intellectual at work, surrounded by everyday objects (like the book, the pen, the inkstand, the sheet of white paper) in the privacy of his study, seeking inspiration with his raised eyes lost in space. The Urbino artist's capacity of identification, as in the case pl. 41 of the later *Portrait of Baldassar Castiglione*, betokens the painter's close friendship with pl. 19 the man of letters glorified in the *School of Athens* under a classical disguise (his cryptoportrait has been identified in the figure of the presumed Orpheus crowned with vine-leaves).

pl. 23 A second painting, which Julius II probably gave to the Roman church of Santa Maria del Popolo, is the deeply tender Chantilly *Veiled Madonna*. In the Bramante chapel of the high altar, a "coemiterium Iulium", that is, an authentic Della Rovere family mausoleum, was being furnished with Andrea Sansovino's tombs, Pinturicchio's frescoes, and Marcillat's stained-glass windows. Proof of Raphael's astounding development during these first Roman years, compared to the nonetheless admirable achievements of his Florentine Madonnas, can be found in the formal innovations that outdo the precedents of the genre: the gesture of the Madonna extending her arm beyond the pictorial surface of the panel, again thrust into the beholder's space; the reflections of the beam of light on the transparent veil rendered with impalpable delicacy; the soft yielding of the flesh of the Child who, almost prefiguring Correggio's angels, sinks in the white sheets as in a light cloud of cotton wadding; introduced by

Raphael at the last minute over what was first a window, the gloom–lit face of aging St Joseph who cannot share the mother's improvised play, all the sorrow of his soul expressed in his blurred features. That play, according to the prescriptions of foresight, can conceal secret symbolic allusions (the veil being the sudary, the awakening of the Child being resurrection), but Raphael's greatness also lies in his supreme ability to dissolve iconographic complexity into transparent solar naturalness.

In the *Galatea* as well, executed toward 1512 for the mighty Sienese banker Agostino pl. 25
Chigi, a patron who in those years could even vie with popes, Raphael demonstrates an astonishing facility in translating into images the classical literary sources advanced by the on–call humanists. Here the *Images* by Philostratus (II, 18) are reinterpreted in light of Politian's *Stanze cominciate per la giostra del Magnifico Giuliano di Piero de' Medici* in a suggestive evocation of the pagan world, evincing Raphael's growing interest for the antiquarian research that ruled Roman culture between the fifteenth and sixteenth centuries without having yet found a satisfying figurative expression. While on the vault of the east loggia of the Farnesina Baldassare Peruzzi displayed a monumental celebration of the patron's horoscope in a cycle of astrological frescoes, Sebastiano del Piombo's work in 1511 in the Ovidian lunettes marked the irruption on the Roman figurative scene of the latest inventions of Venetian painting, revolutionised by Giorgione and the young Titian. In the impassioned *Polyphemus* frescoed on the walls where the *Triumph of Galatea* was to be placed, Sebastiano provided Raphael with the inspiration for a first reaction to the increasingly insistent incentives coming from Venice at the time. Whereas in the Stanza di Eliodoro, as we shall see, confrontation pl. 27
will be imposed on the level of emulation, now, inspired by Sebastiano's frescoes with their figures romantically immersed in the landscape or standing out against clear bright skies, Raphael builds a scene indeed full of air, light and colour. Yet the human figure, expressed in complicated winding poses, relates mostly to Michelangelo's anatomical obsession and to figures carved on antique sarcophagi. The tritons, nymphs and cupids of the *Galatea* in which the patron could make out a ciphered allusion to his love affairs (perhaps his unhappy love for Margherita Gonzaga) still have more to do with the titanic figures of the Sistine Chapel than with the sentimental qualms of Giorgione's school. However, Agostino Chigi's villa, because of a patron's wish to have a direct confrontation between the Roman and the Venetian manners, was where Raphael's new and adventurous *comparaison* began.

In the Stanza di Eliodoro Raphael, having gone beyond the classical height of balance and ease achieved in the Segnatura, means to offer a proud response, that of a henceforth affirmed, undisputed ruler of Roman artistic circles, to the ever more pressing stimuli coming from the most varied sources: he takes cues from Bramante, Michelangelo, classical art, Venetian or northern painting, proving his Olympian skill

in mastering this new composite, stratified 'national' language that was being given to Italian painting as in an ideal compendium.

pl. 26 In the *Expulsion of Heliodorus* the dramatic event is imagined in a complicated setting recalling once again Bramante's designs for St Peter's, yet leaving aside the antiquarian show of the *School of Athens* to concentrate on the fantastic series of flashes and reflections illuminating the vaults and domes of the Temple of Solomon. The ideological focus of the fresco is the impassioned appeal for divine intervention in the figure of the high priest Onius, kneeling in prayer in front of the altar and the holiest symbols of the Hebrews (the seven-branched candelabrum, the arch of the Alliance). The scene is actually designed as the confrontation of two opposite groups: on the right the miraculous irruption of the three divine figures that fall Heliodorus, a Michelangelesque 'barbarian' of overbearing physical strength, emblem of the avarice of earthly princes, on the left the entry on the stage, amidst widows and orphans, of the pontiff himself, who witnesses the event with his retinue but even plays an active role, emphasising the everlasting actuality of the Bible story and the need to reread the events of the past in the light of the present. But the most moving invention of this scene remains the vacuum that opens right at the centre of the fresco, a deep gap grazed, as by a breath, by the shadow of two youths in flight, muscular like the heroes of the Sistine Chapel but suspended in a vortex of air and drapery.

pls. 27, 32 The *Mass of Bolsena*, like the concurrent *Foligno Madonna*, offers an all-out comparison with the obvious chromatic facility Venetian painting had attained, renewed by the turning point represented first by Giorgione and then the young Titian: however great, the names of Lorenzo Lotto and Sebastiano del Piombo, also active on the Roman scene at the time, fail to fully explain the depth of Raphael's intercourse with those masters. In the *Mass of Bolsena* once again Julius II, casting to the winds the cautious moderation shown in the implicit self-glorification in the Stanza della Segnatura, appears beside the protagonist of this medieval miracle. In the first foreground the famed gestatorial chair carriers offer a series of portraits of such psychological intensity, their garb is defined by such vivid synthetic colouring that at this date only the admirable frescoes Titian painted in 1511 for the Scuola del Santo in Padua can explain them. However, the modalities of Raphael's contact with Titian's early chromatic classicism (or Giorgione's late very modern forays), toward 1512, probably the year in which the *Galatea* was painted as a controversial *pendant* to Sebastiano's *Polyphemus*, are still wanting concrete historical elucidation.

pl. 28 The *Deliverance of St Peter* provides an abrupt, unforeseen change of scene. On a perfectly symmetrical stage Raphael displays astonishing directorial skill in alternating narrative moments with different sources of light. The miraculous event erupts in the

dungeon behind the wonderful grating dazzled by the angelic apparition, continues along the right-side stairway that leads St Peter, silently stepping over the sleeping bodies of the guards, toward the space occupied by the beholder, here as well drawn psychologically but also physically to the figures frescoed on the wall. The narrative sequence finally ends to the left of the window on the stairs ideally leading the eye back to the dungeon (at this point imagined empty), climaxing in the emotional reactions of the guards abruptly awakened by the arrival of the changing of the guard. Again this time an external difficulty, the unevenness of the wall, for Raphael became a challenge and an incitement for an utterly innovatory invention. But the truly unforgettable find of this scene is the fantastic shifting of natural and artificial light that vies in virtuosity with the lighting subtleties of northern painting. The silver light of the moon in a cloud-streaked sky, the diffuse light of dawn flushing the horizon, the bright light of the torch held by one of the guards, the sulphurous light radiated twice by the angel's body, the infinite reflections of all these lights on the gleaming armour of the soldiers, originally must have had one more component in the beam of natural light from the window, light filtered and enhanced by further chromatic cues from the stained-glass windows created by Marcillat for the Stanza di Eliodoro. And these experiments must have especially fascinated his peers, as testified by the *Life of Raphael of Urbino* by Paolo Giovio (ca. 1525) where the author's memory, neglecting the correct identification of the subject, focuses on the plays of light: "in the other [room] the soldiers guarding Christ's sepulchre glow with dim light in the very gloom of night". Vasari (1550 and 1568) reiterated and developed this interpretation in a page entirely devoted to the shifting variations of the lights and the difficulties overcome in such a virtuosic invention: and real light vies so well with the one painted by the varied night lights that you have the impression you are actually seeing the smoke of the torch, the splendour of the Angel, with the dark gloom of night so natural and true you would never think the wall was painted, having so aptly expressed such a difficult fancy.

The last fresco on the walls of the room featuring *Attila Repulsed from Rome by Leo X*, pl. 29 completed when a new pontiff, Leo X, and a new policy, peacemaking, had taken over the Roman papacy, found Raphael moving in yet another direction: the archaeological view of Rome evoked in its most famous monuments (Colosseum, the Pyramid of Gaius Cestus, the fluted columns and aqueducts), the antiquarian insistence on the barbarians' arms and costumes, the same frieze-like conception of the scene, imagined as a sequence of figures filing past the onlooker's eyes without illusionistic effects, all elements that state an explicit connection with antique historical reliefs and notably with a monument, Trajan's Column, that in Rome along with the Arch of Constantine was deemed the epitome of this figurative genre. Once again Vasari in the mid-sixteenth century remarked that the horsemen in the foreground with their bizarre

scaled armour moulding their sculptural bodies on stupendous plumed coursers derived directly from those Sarmatians you could admire in two scenes of Trajan's interminable frieze. Besides it was just at that time, around 1514, when the works in the Stanza di Eliodoro were completed and the Incendio yard was beginning, that comparison with the antique, the archaeological Rome hidden in the bowels of the modern one, became more insistent, perhaps responding to the requests from humanist circles in the city who for some time now had been clamouring for an antiquarian-artist who could bring back to life the buried but topical splendours of the classical world.

If in this instance, before leaving the Stanza di Eliodoro, we once again look up pl. 30 at the vault, the small *grisaille* antique-style scenes by Peruzzi's workshop appear overwhelmed by the fantastic capacities of Raphael's inexhaustible mind. In the four curtains that seem to hang like multicoloured tapestries on the architectural partitions, the episodes of the Old Testament, designed as the logical iconographic complement to the scenes painted on the walls, reveal, albeit executed by a collaborator, a new stylistic shift toward those pre-Baroque inventions that would mark the Urbino artist's pl. 48 final period and climax in the Vatican *Transfiguration*: we need but look at the scene of *Moses and the Burning Bush*, the blinding conflagration of flames swirling in the pristine blue of the background, the figure of God the Father, drawn from Michelangelo's brainstorms for the Sistine Chapel, in an irrational vision meant to stir the heart and obliterate the mind.

In the years of the Stanza di Eliodoro Raphael equally executed a series of large altarpieces that mark a complete renewal of that pictorial genre. The first is the so-pl. 32 called *Foligno Madonna*, executed between 1511 and 1512 for the Roman church of Santa Maria in Aracoeli at the time of his infatuation for Venetian painting pl. 27 revolutionised by Giorgione's school and expressed also in the *Mass of Bolsena*. The Madonna with the kicking Child seated on a throne of clouds impresses us as an intensely human epiphany in front of the huge orange-yellow solar disc looming over the entire composition. The literary source is a passage of *Revelation* (12:1) where the Virgin is called "Mulier amicta sole" or an excerpt from Jacopo da Varagine's *Golden Legend* (I, 40–41) recalling the vision revealed to Augustus by the Sibyl ("a gold circle appeared around the sun and in the middle of the circle a resplendent Virgin with a Child on her lap"), while an iconographic suggestion might be Cavallini's fresco that originally adorned the apse of the Roman church of Santa Maria in Aracoeli. However, the chromatic invention appears entirely new in Italian painting. On Earth the donor's portrait is flanked by a series of sacred figures expressing emotionally the part they are taking in the event, involving even the beholder with their gestures. The landscape in the background, lit with fantastic glimmers, teeming with tiny figures that

are almost shapeless specks of colour, is the closest point in all of Raphael's work to that new, sentimental and engrossing vision of nature that Giorgione's painting calls to mind. This suggestive *veduta* was precisely to give rise to the visionary landscapes that would become a specialty of Dosso Dossi.

The *Sistine Madonna*, painted about a year later for the Benedictine church of San Sisto pl. 33
in Piacenza (offering the artists of northern Italy an outstanding example of the new Roman painting), presents an entirely different intent. The beholder's involvement is no longer based on the emotional impact of colour but on a theatrical composition, well-nigh a sacred representation, staged before the stunned eyes of the faithful. The two green drapes – a traditional attribute of the Virgin in medieval Marian iconography – suddenly open onto the afterworld stage, running like a curtain along an iron rod plying under their weight; the Madonna with the Child treads with determined step on the white clouds toward the spectator, while St Sixtus, his tiara set on the stage, stares at this utterly natural apparition indicating with a gesture of his hand the privileged audience, the Benedictine monks seated on the choir stalls who albeit invisible become actors of the sacred image. St Barbara turns her gaze from the Virgin seeking the two cherubs that, almost bored with always playing the same part, rest their elbows on the parapet in the first foreground waiting for the performance to end. Never before in all the history of painting had such a welcoming, embracing altarpiece been seen, so able to seize the faithful's simplest and deepest sentiments. Among the devout thronging round the high altar of the Piacentine church we should fancy a young artist from Correggio who would be everlastingly thunderstruck by this tenderest of divine apparitions.

Another year and toward 1514, with the *Ecstasy of St Cecilia* for the Bolognese church pl. 37
of San Giovanni in Monte, Raphael wrought another change in the genre of the altarpiece, breaking new ground and trying out yet unexplored possibilities. The image appears to play entirely on the visual contrast created between the saint, ecstatically turned toward the afterworld and immersed in the mystical harmony issuing from the angelic choir cleaving through the blue of the sky in a blaze of divine light, and the other figures manifesting their earthly nature in their gestures and expressions: St Paul, plunged in meditation, Magdalene her eyes on the faithful, the Sts John the Evangelist and Augustine in the background engaged in a mute exchange of gazes. But the most innovatory detail of the work, in which is concealed one of the roots of a genre – the still life – that did not yet exist in Italian art, is the musical instruments placed in the first foreground. With these abandoned 'posing' instruments, set aside to illustrate the overcoming of human music (the wood of the violin is rotting, the chords are broken, even the small organ held by St Cecilia has its keyboard smashed and pipes falling apart), Raphael amazes us once more by his direct contact with reality, for which he

often is not recognised. Even Vasari solved the problem of harmonising the artist's 'classical' image with the still life of *St Cecilia* by assuming the intervention of a specialist like Giovanni da Udine in that part of the picture.

On examining the major works executed toward 1513 we discover the marvellous flexibility of Raphael's genius, his capacity to constantly change, complying of course with outside stimuli (patrons' wishes, expectations of the public, occasionally prevailing stylistic influences) yet always retaining the capacity, truly incomparable in the entire history of art, to create normative images that will serve as models for entire generations of artists and influence in depth the collective imagination. Frescoed on a pillar of the church of Sant'Agostino, where in 1512 Johann Goritz, whom the Roman humanists glorified under the name Coricio, had placed a manifesto of Andrea

pl. 31 Sansovino's sculptural classicism, the *Prophet Isaiah* represents the Urbino artist's most earnest, open tribute to the titanic figures Michelangelo gathered to throng the vault of the Sistine Chapel. It is as though Raphael, as in his youth with Perugino, now wanted to challenge the tormented Florentine artist on his own ground. However, the design for the decoration of the funerary chapel of Agostino Chigi at Santa Maria del

pl. 36 Popolo, merging painting, sculpture and architecture in a sort of anticipation of the Baroque 'total work of art' and illusionistically creating a dialogue within the sacred space, as though it were a stage, between the figures painted on the altarpiece, the ones carved in the niches and the mosaics in the partitions of the ceiling, introduced a decorative concept that can be considered antithetical with respect to the anti-perspective, anti-unitary one for the Sistine Chapel.

pl. 35 Again toward 1513–14 with the *Madonna of the Chair*, Raphael completed the research already initiated in his Florentine years that sought to combine the utmost artlessness of feeling with the greatest compositional refinement. The huge popular success of this painting can be explained by the appealing sweetness of the gestures and expressions at the same time as the extremely elegant arrangement of the forms, admirably adjusted to the discipline imposed by the form of the tondo. Revisiting a sculptural model by Michelangelo (the Pitti tondo in the Bargello) Raphael is able to suggest to the beholder the Virgin's prophetic foresight as she protectively holds the Child in her arms, seated on a 'Chamber Chair' typical of the pontifical dignitaries, while at the same time recalling the eternal gesture of every mother gently rocking her babe.

pl. 34 At the same time Raphael with *La Velata* carried to extremes the freedom of touch
pls. 32, 27 previously found in the *Foligno Madonna* and the *Mass of Bolsena*, that probably should be considered a response to cues from the Giorgione school of Venice and the Terraferma. The sensational sleeve in the first foreground, superbly contrasting with the quietness of the veil, the background and the expression of the face, is painted with a colour that ripples, vibrates and shifts before our eyes in a pictorial

impasto where emotion seems to flow directly onto the canvas, for once ignoring every intellectual restraint.

1 AUGUST 1514 – 6 APRIL 1520: "A GREAT LOAD UPON MY SHOULDERS"

On 1 August 1514, following Bramante's death, Raphael was officially appointed papal architect by Pope Leo I, together with two older masters, Fra Giocondo (1433–1515) and Giuliano da Sangallo (ca. 1440–1516), who were to assist him with their wealth of technical skills, their antiquarian culture ripened in years of studies on Vitruvius's *De Architectura* and the monumental remains of ancient Rome. At that date Raphael's actual experience in architecture was very scarce: a few projects for Augusto Chigi that went back to earlier years (the loggia on the Tiber and the stables in the Farnesina gardens, the funerary chapel in Santa Maria del Popolo) must have convinced of his concrete gifts in the field. Indeed the first words attributed to Raphael, right after the appointment, in a letter in which Castiglione outlines a sort of intellectual portrait of his recently departed friend, are those of an ambitious artist but one well aware of his own limits: "I would like to find the beautiful forms of classical buildings yet I don't know if it will turn into Icarus' flight. Vitruvius gives me great enlightenment but maybe not enough." Old Fra Giocondo ("a man of great repute and knowledge") would be the one to create Raphael's link with the fabulous world of ancient Rome, helping the Urbino artist to "learn" all the secrets of architecture and become "ultra perfect" in that art as well.

Raphael's first design for the new St Peter's basilica dates to the summer of 1514. On 1 July, Fra Giocondo died and Giuliano da Sangallo returned to Florence, so Raphael was left on his own in charge of the Fabbrica di San Pietro. But the appointment to first papal architect implied far more complex duties: not only overseeing all the Vatican buildings under way or being restored, organising the conservation of the monuments of ancient Rome and the town-planning of modern Rome, but also closely supervising the most important pontifical commissions of pictorial and sculptural projects. This "great load upon my shoulders", to quote words put in Raphael's mouth again by Castiglione, explains why henceforth the artist, ever more sought after by illustrious patrons all over Europe, had to increasingly delegate the execution of his pictorial works to his workshop. Raphael succeeded in attracting first-rate collaborators, and owing to an ensemble of highly diversified skills they were able to take on the most varied tasks, always under the attentive unifying control of the master.

If the presence of assistants at the master's side became increasingly obvious from the time of the decoration of the Stanza dell'Incendio onward, the first fresco, the *Fire in*

pl. 38 *the Borgo* that gave the room its name, shows that for Raphael 1514 was the year in which he attained to the new 'tragic style' featuring an intensely dramatic eloquence. This fresco underscores the meaning of the political change accomplished during the Medicean pontificate of Leo X, who was determined to bring peace after the convulsed years of Julius II. The scene, set in medieval Rome, in the district around the old basilica of St Peter where a fire had broken out and was miraculously extinguished by Pope Leo IV, gave him the opportunity to unfold a composition that appears overwhelmed by the roaring blaze of the flames, assailing the draperies and terrifying the crowd. On the left the figures fleeing the fire recall the Virgilian group of Aeneas carrying Anchises and Ascanius out of burning Troy, referring to the theme of the founding of Rome, dear to a pope who wished to be the creator of a new Rome. At the same time these nudes are a new challenge to Michelangelo but without the slightest psychological awe, assimilating the most difficult traits of that formal language in a composite, layered idiom that speaks to the onlooker with the power of impassioned oratory.

Toward the end of 1514 the commission for a series of cartoons for the tapestries of the Sistine Chapel, at the behest of a pontiff who wished to present himself anew as the restorer of the greatness of ancient Rome, was surely for Raphael a wonderful opportunity to permanently settle accounts with the thundering frescoes of the vault Michelangelo completed but two years before. In the seven surviving cartoons as well as in their translation executed by a weavers' workshop in Brussels, the artist achieved a language grandiose yet devoid of rhetorics, extremely learned but devoid of pl. 40 intellectualism. In the *Miraculous Draught of Fishes*, the physical energy of the athletic figures of the fishermen contrasting with the impassive stillness of Christ rivals Michelangelo's anatomical displays. But the event is set in a pacified landscape where the reflecting water of the lake and the clear blue of the sky embrace the new naturalistic interests that Raphael's workshop harboured in part thanks to the presence of an expert like Giovanni da Udine (to whom the detail of the three cranes on the shore and the fish wriggling in the boats has been ascribed).

pl. 39 In the *Battle of Ostia*, the last fresco executed for the Stanza dell'Incendio but designed by Raphael ca. 1515 [fig. 5], all the normative strength of the antique models surfaces at a time when he was developing a highly emphatic oratorical idiom. The interlacing in the foreground of the bodies of the soldiers and captives arranged as in the frieze of a classical sarcophagus or a historical relief, along with the display of antiquarian erudition in the ships facing up to one another in the background, show to what degree Raphael in the last years of his life wished to further his knowledge of classical culture by systematically and passionately studying Rome's monumental remains. Soon ancient sculpture, painting and architecture would hold no more secrets for him and humanists

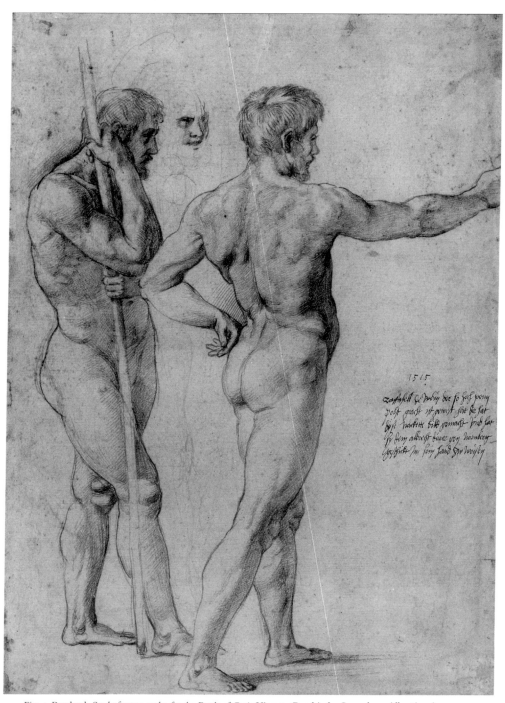

Fig. 5. Raphael, *Study for two nudes for the Battle of Ostia*, Vienna, Graphische Sammlung Albertina, inv. 17575.

all over Italy would be able to hail the birth of a new type of antiquarian-artist that the Renaissance had not yet encountered at this level. Another confirmation in these years, availing of Marcantonio Raimondi's skilled burin, comes from a set of engravings that, aside from popularising the fame of the Urbino artist's ultra-modern formal inventions, must have been viewed with emotion for their wealth of archaeological learning. Just think, for instance, of the *Quos Ego* [fig. 6], the etching where Raphael, borrowing from the classical *tabulae iliachae*, drew up a visual summary of the entire first book of Virgil's *Aeneid*, in which words and images dialogue intimately in an authentic tribute to classical literary erudition. Only a man of letters of the period with a close familiarity with the poem could decodify so intricate an image in which Raphael utilised every possible source (including the late-classical miniatures of the *Vatican Virgil* and the *Roman Virgil*) to embody the humanist dream of the rebirth of the classical world.

Raphael's relationship with the circles of humanists and men of letters gravitating around the papal court, essential if we wish to understand the intellectual depth of many of his creations, and especially evident in these last years, was expressed in portraiture, notably in the painting celebrating his friendship with Baldassar pl. 41 Castiglione. In this portrait the Urbino ambassador, distinguished poet, brilliant inventor of the *Book of the Courtier*, has his intellectual bond with the painter glorified without calling upon the stereotypes of the image of the man of letters at work (as in pl. 24 the portrait of Inghirami). Here Raphael merely suggests the close bond of friendship between him and Castiglione, depicting him as a serene amiable man, unassumingly wrapped in soft, elegant winter clothes, almost as if the humanity of the person was not to be distracted by external emblems. The writer's clear gaze is fixed on the painter: it is as if a dialogue had just been broken off, as if the two intellectuals had suspended their reflections for a moment. A dialogue of this nature between Raphael and Castiglione gave rise several years later to the letter to Leo X on classical architecture that can be seen as a sign of the new alliance that, in light of the prestige of ancient Rome, had been founded between artists and writers. An alliance that we can almost feel on recalling the excursion to Tivoli to visit the ruins of Villa Adriana that five friends made in the spring of 1516: four writers (Pietro Bembo, Andrea Navagero, Agostino Beazzano and Castiglione) with an artist like Raphael who, although not sharing his father's literary ambitions, had composed several sonnets in the style of Petrarch toward 1509–10.

On 16 June 1519 Castiglione would be the one to announce in a letter to Isabella d'Este, marquise of Mantua, the completion of the decoration of a loggia in the pl. 43 Vatican Palaces, "painted and stuccoed in the antique style, a work by Raphael, the most beautiful that can be and perhaps more than what we see today by moderns". Actually Raphael had barely touched the executive phase of this project, probably

begun in 1517, content to design a new decorative system (already tried out in 1516 in the Vatican apartment of Cardinal Bibbiena), so archaeologically authentic as to amaze Roman humanist circles. Even more than the Bible scenes in the vaults and the *grisailles* that formerly ornamented the baseboard, conceived as a simple popular tale from sacred history, the white antique-style stuccoes executed by Giovanni da Udine, finally revealing one of the classics' technical secrets and wonderfully bringing back to life innumerable pagan iconographies, must have convinced commissioners that Raphael had at last breached the gap separating the moderns from the ancients. In 1517 for instance one of the greatest early sixteenth-century Italian patrons, Duke Alfonso d'Este of Ferrara, would

Fig. 6. Marcantonio Raimondi (after Raphael), *Quos Ego* (ten episodes from the first book of Virgil's *Aeneid*), Vienna, Albertina.

intensify the efforts of his ambassadors in Rome to obtain from Raphael the large mythological painting commissioned to him three years earlier, the *Indian Triumph of Bacchus* based on a refined collection of visual and antiquarian sources (Dionysian sarcophagi, the *Dialogues* and the *Opuscula* by Lucian). The work, that should have been placed in the 'camerino d'alabastro' next to the bacchanalia of Giovanni Bellini, Titian and Dosso Dossi, as though to juxtapose the most modern figurative expressions in Italy, was never executed, but preparatory drawings and replicas of Raphael's invention [fig. 7] document the constant growth of the artist's archaeological erudition. Furthermore during these years Raphael launched his most ambitious antiquarian project (and the most lamented by humanists at the artist's death in April 1520): the graphic reconstruction, plan, elevation and section, of the monuments of the fourteen areas of ancient Rome. A grandiose project based on the examination of literary sources, topographical surveys and actual archaeological research. We gain a notion of it in scanning the so-called Fossombrone Codex, a book of drawings in which an artist close to Raphael, doubtless shortly after his death, copied a whole series of the master's studies and designs. If a few sheets allow us to appreciate Raphael's Vitruvian studies for a new illustrated edition of the *De Architectura*, in other cases the drawings bring back to life before our eyes the wonders of Roman architectures, recalling, as for the *frigidarium* of Diocletian's Thermae [fig. 8], their spatial grandeur but their decorative magnificence as well.

The two main quests Raphael pursued in his last years, that is, the perfecting of a formal language together antiquarian and tragic, grounded on an increasingly profound intimacy with the secrets of ancient art and expressed with a new dramatic intensity to captivate the beholder intellectually and enthrall him emotionally, reach their utmost in his last works, open onto the future of painting even beyond the sixteenth century. In the Loggia of Psyche painted for Augusto Chigi at the Farnesina, Apuleius's tale gives the artist and his collaborators the occasion to conceal the patron's pl. 46 love affair in the myth: Mercury announcing to the world Psyche's banishment leaps out of the walls, invading the space of the loggia open onto the viridarium of the Villa, in a scenographic invention that appears again, transfigured in a mystical pl. 47 explosion of light, in the *Vision of Ezekiel*. In portraiture as well we observe a gradual pl. 44 intensification of strategies involving the beholder. If the portrait of Pope Leo X revises the model perfected for Julius II by focusing on the intellectual appearance of the commissioner, heir of the great Medici patronage, busy examining a precious pl. 45 illuminated manuscript and flanked by two cardinals of his court, the double portrait of Raphael with a friend invades the space of the beholder drawn inside the painting by the finger pointed at him, as though he were a accessory needed to complete the effect of the work.

The height of Raphael's "tragic style" can be seen in *Lo Spasimo di Sicilia* or *Christ* pl. 42 *Falls on the Way to Calvary*, which turns the drama of Christ mounting to Calvary into a crowd of powerfully expressive figures accentuating to a paroxysm the ges- pl. 48 tures of the dramatic action, and even more so in the *Transfiguration*. A work that concludes an incredibly vast figurative trajectory and at the same time opens prophetically onto research that would be not be successfully concluded until a century later. The deafening burst of emotions expressed by the glaring light emanating from Christ that deflagrates in the upper section, blinding the apostles and transfixing the prophets, is an essential precedent for the Italian Rubens's quest for a style based on the antique and the early sixteenth-century masters, but at the same time deeply emotional, in an explicitly proto-Baroque direction. In the figures of the apostles, steeped in the darkness thickening on the slopes of Mount Tabor, highlighted by sudden blasts of light, in the faces taken from life where light and shadow cruelly reveal the skin, in this aggressive, almost provocative objectivity could lie one of the sources (even more striking when the work towered over the high altar of the church of San Pietro in Montorio, lit by the tremulous wavering candles) of the revolution the young Caravaggio accomplished after his decisive and never forgotten pilgrimages in Lombardy, tirelessly scouring the fabulous streets of Rome: a city that could offer an unforeseen naturalistic inspiration even in the final work of the painter always deemed 'classical' *par excellence*, Raffaello Sanzio da Urbino.

EPILOGUE: ACTUALITY OF RAPHAEL

In 1884 Pierre Puvis de Chavannes, decorating the stairway of the Musée des Beaux-Arts of Lyon, painted the *Sacred Wood Dear to the Arts and the Muses* [fig. 9, p. 121]: a large composition meant to replicate Raphael *sur nature*, dissolving the dense scene of the *Parnassus* in a more diffused, serene rhythm in the tradition of French classicism that we recognise in the lesson of Poussin.

Twilight descends, Apollo has withdrawn from his garden, the nine Muses, indolent and meditative, with the three Arts weave a mute play of gazes and gestures in an Arcadian landscape where the green grass

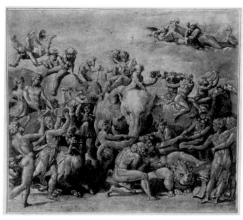

Fig. 7. Conrad Martin Metz (after a drawing by Raphael), *Indian Triumph of Bacchus*, reverse acquatint from *Imitations of Ancient and Modern Drawings*, London 1789, fol. 51.

is reflected in the golden waters of the lake. All is calm, repose and silence. While in Paris modernism throbs, here in Lyon a timeless world prevails, a golden age contemplated with heartfelt nostalgia. But the artist's vibrant sentiment corrodes the forms, dilutes the colours, synthesises the compositions. The strokes of colour become ever swifter, more allusive, building a classicism that indeed starts with Raphael, overcoming the anxieties and contradictions of the present but to plunge unawares into the twentieth century: a highly scholarly painting, yet steeped in emotion, that would become an essential model for the various movements of the return to order and the recovery of tradition that marked the contradictory history of the century that just closed. A modernism that does not refuse the museum but that, in the secular history of painting and one of its outstanding protagonists like Raphael, finds a thrilling reservoir of 'perfect' forms in which even the present can be reflected.

An 'academic' interpretation of Raphael, as the case of Puvis also proves, is absolutely misguided: in his ardent course of his life the Urbino artist evolved as only very few others did. Raphael's contemporaries already realised his career was a perpetual metamorphosis. Beltrando Costabili, bishop of Adria and orator from Este, writing on 4 November 1517 to the duke of Ferrara, Alfonso d'Este, precisely pointed out this constant 'improvement' to be found in his works: "He says he will do something very excellent, and I believe it, because in his work you can always see him improving and I feel it is a good thing he tarried until now to serve your Excellency."

Raphael should not only be seen as the genius of 'combination', the synthesis between opposite polarities. He was also the genius of change, of assimilation, of curiosity: he possessed a constant urge to experiment that questioned the outcomes even when they were apparently 'perfect' and praised by his patrons, always engaging in new intellectual challenges.

In 1920 André Derain, right in the midst of the return to order, musing on the distortion of the widespread image of the artist, claimed Raphael was "the most misunderstood", warning young artists to approach this model, that could spoil even the best talents, only "with the utmost caution":

"Raphael is the most misunderstood! Raphael is not a master for the young: he cannot be a school for beginners. You should only approach Raphael after a great many disappointments! If you start with him it's a disaster, he is a genius that

Fig. 8. Anonymous draughtsman in Raphael's circle, *Reconstruction of the elevation facing the* natatio *of the frigidarium of Diocletian's Thermae*, Fossombrone, Biblioteca Civica Passionei, Codice di Fossombrone, fol. 16 r.

can spoil even the greatest. There are some sad examples. Besides his influence was nonexistent for over a century [...] Raphael is above Vinci who is a cunning schemer and, far from being divine, has a certain taste for rot. Raphael alone is divine!"

LIST OF PLATES

pl. 1. *Head of an Angel* (fragment of the *Coronation of St Nicholas of Tolentino*), 1501, oil on panel mounted on canvas, 31 x 26.5 cm, Brescia, Pinacoteca Tosio Martinengo, inv. 149.
The altarpiece of St Nicholas of Tolentino, commissioned to Raphael and Evangelista da Pian di Meleto by Andrea Baronci for the church of Sant'Agostino at Città di Castello, was completed on 13 September 1501. Damaged by the 1789 earthquake, there are four surviving fragments: two in Naples (Museo di Capodimonte) and one in Paris (Louvre), as well as the *Head of an Angel* purchased by count Paolo Tosio on the Florentine antiquarian market toward 1822 and donated in 1844 to the Brescia municipal collections.

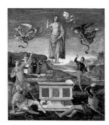

pl. 2. *Resurrection of Christ*, ca. 1501–2, oil on panel, 52 x 44 cm, São Paulo (Brazil), Museu de Arte de São Paulo Assis Chateaubriand (MASP), inv. 17.1958.
The painting, discovered in 1880 when it was the property of Lord Kinnaird at Rossie Priory (Perthshire, Scotland and originally in the Mignanelli collection in Siena), entered the museum of São Paulo in Brazil in 1954. At that time, its connection with two drawings of the Ashmolean Museum of Oxford, preparatory for the figures of the Roman soldiers (confirmed by the recent discovery of a new study for the *Christ Risen* in the Biblioteca Oliveriana of Pesaro), made its attribution to Raphael toward 1501–2 increasingly creditworthy.

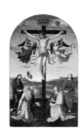

pl. 3. *Gavari* (or *Mond*) *Crucifixion*, ca. 1503, oil on panel, 280.7 x 165 cm, London, National Gallery, inv. 3943.
The *Crucifixion*, part of the altarpiece for the San Girolamo chapel in San Domenico at Città di Castello that comprised a predella (two small panels are in Lisbon and at Raleigh, North Carolina), was purchased in 1808 by Cardinal Fesch and in 1924 entered the National Gallery (in 1892 it belonged to Ludwig Mond). The inscription on the original stone frame ("HOC OPUS FIERI FECIT D[omi]NICUS THOME DE GAVARIS M D III") specifies the name of the patron and the probable year of its execution; the signature ("RAPHAEL URBINAS P[inxit]") is at the foot of the Cross.

pl. 4. *Coronation of the Virgin* (from the Oddi altarpiece), ca. 1503, oil on panel mounted on canvas, 267 x 163 cm, Vatican City, Pinacoteca Vaticana, inv. 334.
The *Coronation of the Virgin*, part of the altarpiece executed for the Oddi chapel in San Francesco al Prato at Perugia, was commissioned by Alessandra Baglioni, wife of Simone degli Oddi, along with the predella (also at the Pinacoteca Vaticana): taken to Paris in 1797, it was removed to Rome in 1815. Its chronology is the object of controversy: usually dated to 1503, a recent hypothesis places the execution of the upper section to ca. 1502 and that of the lower section to the first months of 1504.

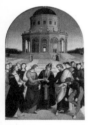

pl. 5. *Marriage of the Virgin*, 1504, oil on panel, 174 x 120.6 cm, Milan, Pinacoteca di Brera, inv. 472.
The work, commissioned by Filippo Albizzini for the San Giuseppe chapel in San Francesco at Città di Castello, remained in its original setting until 1798, when it was acquired by the Brescian Giuseppe Lechi. In 1806, after passing through several hands, it was purchased by Viceroy Eugène de Beauharnais for the Pinacoteca di Brera. The signature "RAPHAEL URBINAS" visible on the frieze of the portico surrounding the temple should be interpreted, as well as the date "MDIIII", as openly self-assertive.

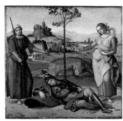

pl. 6. *Vision of a Knight* (*The Choice of Hercules*), ca. 1504, oil on panel, 17 x 17 cm, London, National Gallery, inv. 213.
Prior to 1633 the painting is cited in the Borghese collection; sold in Rome in the late 18th century, it entered the National Gallery in 1847. The patron is not known: the connection with Scipione di Tommaso Borghese is a mere assumption. Instead we are certain it derives from an illustration in an edition of the *Ship of Fools* by Sebastian Brant (Nuremberg 1497) where the theme of *Hercules at the Crossroads* underscores the conflict between Vice and Virtue and therefore the choice the young mythological hero is urged to make.

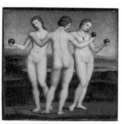

pl. 7. *The Three Graces* (*The Hesperides with the Golden Apples*), ca. 1504, oil on panel, 17 x 17 cm, Chantilly, Musée Condé, inv. 38.
The painting, by its provenance (the Borghese collection, where it is mentioned prior to 1633) and dimensions, is held to be part of a diptych together with the *Vision of a Knight* [pl. 6]; from Rome it was removed to France in the late 19th century. The iconography derives from an antique group with the *Graces* that in 1502 arrived from Rome to Siena, in the Piccolomini Library; however the golden apples held out by these figures are more closely related to the Hesperides and the mythical garden that was the setting for one of the last of Hercules' labours.

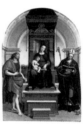

pl. 8. *The Madonna and Child enthroned flanked by Sts John the Baptist and Nicholas of Bari* (from the Ansidei altarpiece), ca. 1505, oil on panel, 209.6 x 148.6 cm, London, National Gallery, inv. 1171.
The altarpiece, that comprised a predella of which one section remains, it also at the National Gallery, was probably commissioned by the brothers Niccolò and Giovanni Ansidei for the San Nicola di Bari chapel in San Fiorenzo at Perugia. In 1764 it passed to England, entering the National Gallery in 1885. Dating, based on an inscription on the hem of the Virgin's cloak ("MDV" or "MDVI"), is not ascertained: doubtless the work was commissioned in 1504 and completed in the following years.

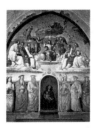

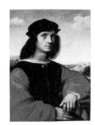

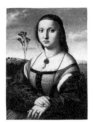

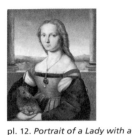

pl. 9. *The Trinity with Saints*, 1505, fresco, 445 x 389 cm, Perugia, San Severo.
The fresco, as indicated by two inscriptions, was begun in 1505 by Raphael ("RAFAEL DE URBINO [...] PINXIT A D [M] D V") and completed by Perugino in 1521 ("PETRUS DE CASTRO PLEBIS PERUSINUS [...] PINXIT A D MDX[XI]") with the six figures in the foreground. Thus the work attests the difference between the two artists: the younger painter reflects the depth of his first Florentine meditations, the older master confirms his stubborn blindness to the production of the "modern manner".

pl. 10. *Portrait of Agnolo Doni*, ca. 1506, oil on panel, 65 x 45.7 cm, Florence, Palazzo Pitti, Galleria Palatina, inv. 61.
Agnolo Doni, who in 1504 had married fifteen-year old Maddalena Strozzi, was a well-to-do tradesman, but equally an enthusiastic collector who had assembled a significant selection of artworks, antique and modern, including Michelangelo's famous *Tondo Doni*. The pair of portraits [pl. 11], kept at length by the family, then in the 18th century removed perhaps to Rome and then secretly to France, was returned to Florence in 1826 by Grand-Duke Leopold II and exhibited at Palazzo Pitti.

pl. 11. *Portrait of Maddalena Strozzi Doni*, ca. 1506, oil on panel, 65 x 45.8 cm, Florence, Palazzo Pitti, Galleria Palatina, inv. 59.
The monochromes on the verso of the two portraits, attributed to the so-called Master of Serumido, depict episodes from the myth of Deucalion and Pyrrha: the deluge sent by Zeus to punish mankind and the creation by Deucalion and Pyrrha of a renewed human race. The mythological theme refers to the motif of fecundity, topical for a couple who had their first child in 1507: it might be a good omen, in confirmation of the dating based on style, toward 1506.

pl. 12. *Portrait of a Lady with a Unicorn*, ca. 1506, oil on panel mounted on canvas, 67.7 x 53.2 cm, Rome, Galleria Borghese, inv. 371.
The painting, the property of Olimpia Aldobrandini, entered the Roman collection through her marriage to Paolo Borghese. It might match the "Santa Caterina" by "Raffaelle" in the 1615–30 inventory; actually it was overpainted, the lady becoming St Catherine of Alexandria. In 1927 Longhi suggested the attribution to Raphael, confirmed by the restorations of 1934–35 and 1959–60. The hypothetical dating to 1506 is grounded on the connection with the *Mona Lisa*, even more apparent in the Louvre preparatory drawing.

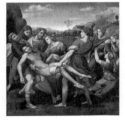

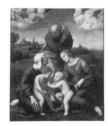

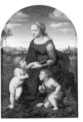

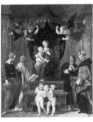

pl. 13. *Entombment* (from the Baglioni altarpiece), 1507, oil on panel, 184 x 176 cm, Rome, Galleria Borghese, inv. 170.
The altarpiece, commissioned by Atalanta Baglioni, was executed for the San Matteo chapel in San Francesco al Prato at Perugia. The preparatory drawings must date for the most part to 1506, whereas the central panel bears the signature and the date 1507 ("RAPHAEL URBINAS MDVII"). The work was dismembered in the early 17th century: the largest panel was conveyed to Scipione Borghese in 1608. Other fragments are in Rome (Pinacoteca Vaticana), whereas the authorship of the Perugia panel (Galleria Nazionale dell'Umbria) is controversial.

pl. 14. Canigiani *Holy Family*, 1507, oil on panel, 131 x 107 cm, Munich, Alte Pinakothek, inv. 476.
The painting, signed on the neckline of the Virgin's garment ("RAPHAEL URBINAS"), was commissioned by Domenico Canigiani, a Florentine draper, doubtless on the occasion of his wedding in 1507 with Lucrezia Frescobaldi. The work, entered in the Medicean collections in the late 16th century, was offered at the end of the 17th century to the Palatine Elector Giovanni Guglielmo and remained in Düsseldorf until the early 19th century, then passing to the Alte Pinakothek in Munich in 1836.

pl. 15. *Madonna and Child with the Infant St John* (the *Belle Jardinière*), 1508, oil on panel, 122 x 80 cm, Paris, Musée du Louvre, inv. 602.
The work, signed on the hem of the Virgin's cloak ("RAPHAELLO URB"), was probably executed in 1508 for an unknown patron: the names of the Sienese Filippo Sergardi and the Florentine Taddeo Taddei have been advanced. Passed in France in the 16th century, after belonging to Louis XIV it entered the Louvre in 1793. It represents a peak in Raphael's reflections on the theme of the Madonna and Child and the Infant St John, initiated in 1505–6 with the *Madonna and the Goldfinch* and the *Madonna of the Meadow*.

pl. 16. *Madonna del Baldacchino*, 1508, oil on panel, 276 x 224 cm, Florence, Palazzo Pitti, Galleria Palatina, inv. 165.
Commissioned by Pietro Dei, probably in 1506, for the family chapel in Santo Spirito in Florence, the altarpiece remained incomplete, in an advanced state of execution, at the time of Raphael's departure for Rome in 1508. Purchased by Baldassare Turini, Raphael's executor from Pescia, it was placed in the cathedral of Pescia; in 1697 it passed to Ferdinando de' Medici entering Palazzo Pitti, where, integrated at the top with a 32-cm strip by Niccolò Cassana, it still is.

pl. 17. *Vault of the Stanza della Segnatura*, 1508–11, fresco, 820 x 640 cm, Vatican City, Palazzi Vaticani.
The vault of the Stanza della Segnatura was painted in two stages: in 1508 Sodoma frescoed the central oculus and the eight small curved spaces; doubtless when the frescoes on the walls were almost completed, toward 1510–11, Raphael completed it with the personifications of *Theology*, *Poetry*, *Philosophy*, and *Justice* in the tondi and with the scenes of the corner panels (*The Fall of Man*; *The Flaying of Marsyas*; *Astrology announces the Advent of Julius II to the Pontificate*; *Solomon's Judgement*).

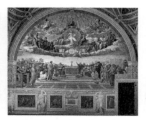

pl. 18. *Disputation of the Most Holy Sacrament*, 1508–9, fresco, 770 cm base, Vatican City, Palazzi Vaticani, Stanza della Segnatura.
The *Disputa* has been considered, ever since Bellori (1695), the first fresco Raphael executed in the stanza, between 1508 and 1509; regarding the recent attempt to render credibility to Vasari (1550 and 1568), who placed the *Disputation* after the *School of Athens* [pl. 19], it should be recalled that in this particular scene, and notably in the figures of Christ and the angels of the upper register, a connection with models by Perugino assimilated by the artist during his early career is still evident.

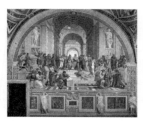

pl. 19. *School of Athens*, 1509–10, fresco, 770 cm base, Vatican City, Palazzi Vaticani, Stanza della Segnatura.
The preparatory cartoon at the Pinacoteca Ambrosiana of Milan and recent technical investigations reveal that the so-called 'thoughtful one', the presumed Heraclitus seated in the foreground, must have been added, probably in the summer of 1511, in homage to Michelangelo. The introduction of this figure, in a scene already presenting Raphael's self-portrait and the effigy of Euclid-Bramante, completes the glorification of the three great artists who, in those years, were working in the Vatican.

pl. 20. *The Wall of the Parnassus*, 1511, fresco, 670 cm base, Vatican City, Palazzi Vaticani, Stanza della Segnatura.
The wall of the *Parnassus* features two *grisailles* representing *Alexander the Great causes Homer's Iliad to be placed in Dario's Coffin* and *Augustus prevents Virgil's Executors from destroying the Aeneid*. Apollo, the classic God who inspires the Muses, and the two great figures of Greek and Roman history who paid tribute to the greatest poets of Antiquity were to embody and glorify Julius II's patronage in the field of literature.

pl. 21. *The Wall of Justice*, 1511, fresco, 660 cm base, Vatican City, Palazzi Vaticani, Stanza della Segnatura.
The wall is divided in three sections: in the lunette are placed the personifications of three cardinal Virtues (*Fortitude*, *Prudence*, *Temperance*); in the small scene, at the left of the window, where *Tribonian presents the Pandects to Justinian*, the hand of an assistant has been assumed; the large scene, where *Gregory IX approves the Decretals presented to him by San Raimondo di Peñafort*, is the climax of the glorification of Julius II, identified with the medieval pope.

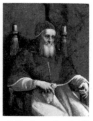

pl. 22. *Portrait of Julius II*, ca. 1511, oil on panel, 108 x 87 cm, London, National Gallery, inv. 27.
The painting, donated by Julius II to the Roman church of Santa Maria del Popolo together with the *Veiled Madonna* [pl. 23], passed in 1591 to Cardinal Paolo Camillo Sfondrato and in 1608 to Scipione Borghese; sold in England at the end of the 18th century, it was purchased by the National Gallery in 1824 and only identified as from Raphael's own hand after its restoration in 1970. By the presence of the flowing beard it should be dated to 1511, perhaps after 27 June, when Julius II returned to Rome from Bologna.

pl. 23. *Veiled Madonna* (or *Loreto Madonna*), ca. 1511, oil on panel, 120 x 90 cm, Chantilly, Musée Condé, inv. 40.
As the *Portrait of Julius II* [pl. 22], the painting passed from Santa Maria del Popolo to cardinal Sfondrato in 1591 and to Scipione Borghese in 1608; conveyed to the prince of Salerno and, in 1854, the duc d'Aumale, it was given in 1884 to the Musée Condé of Chantilly and not identified as an original by Raphael until 1979. The most likely dating, for reasons of style, appears toward 1511, even though a copy of the painting (at Nishnij-Tagil, Ural) bears the inscription "RAPHAEL URBINAS PINGEBAT MDIX".

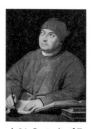

pl. 24. *Portrait of Tommaso Inghirami (known as Fedra)*, ca. 1511, oil on panel, 89.5 x 62.3 cm, Florence, Palazzo Pitti, Galleria Palatina, inv. 171.
The painting is cited in the Medicean collections between 1663 and 1667; exhibited in the Gallery and mentioned in 1692 in the Tribune, in 1697 it was sent to Pitti (where it adorned, in 1723, the Camera dell'Alcova). After a forced stay in Paris (1799–1816), it returned to Palazzo Pitti and was shown in the Saturn Room. The portrait was probably executed by Raphael toward 1511, right after the appointment of Tommaso Inghirami, famed orator and Volterra poet, as prefect of the Vatican Library (17 July 1510).

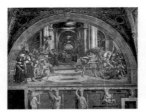

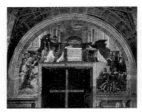

pl. 25. *Galatea* (with the *Polyphemus* by Sebastiano del Piombo), ca. 1511–12, fresco, 295 x 225 cm, Rome, Villa Farnesina, sala di Galatea (or Loggia of the Planets).
The fresco was executed for the Sienese banker Agostino Chigi in a loggia of the suburban Villa in which had already worked, ca. 1510–11, Baldassarre Peruzzi, with the astrological cycle of the vault, and Sebastiano del Piombo, with the Ovidian lunettes devoted to myths associated with the theme of air and the fresco representing *Polyphemus*: the latter appears to be linked iconographically with the *Galatea*, since the cyclops appears lost in contemplation of the nymph with whom he had vainly fallen in love.

pl. 26. *Expulsion of Heliodorus from the Temple*, 1511–12, fresco, 750 cm base, Vatican City, Palazzi Vaticani, Stanza di Eliodoro.
The stanza known as di Eliodoro, owing to the subject of this first fresco, was for the papal Audience: the themes are more explicitly 'political', remaining within an iconographical programme praising the Della Rovere pontificate. Here divine intervention is suggested by an episode from the Old Testament (1 Macc. 2:3): thanks to the prayers of the high priest Onius the angels (a horseman with golden armour and two youths with whips) expel the 'barbarian' enemy, Heliodorus, from the Temple of Jerusalem.

pl. 27. *Mass of Bolsena*, 1512, fresco, 660 cm base, Vatican City, Palazzi Vaticani, Stanza di Eliodoro.
In the *Mass of Bolsena*, painted taking advantage of the asymmetrical shape of the wall, the miracle of the bleeding of the Host once again allows Julius II, as in the *Expulsion of Heliodorus from the Temple* [pl. 26], to take part in the event personally, in the stead of Urban IV who attended it in 1263: the pontiff is kneeling in front of the altar where the unbelieving priest is ascertaining the prodigy, while behind him are arrayed the cardinals of the retinue and, in the foreground, the 'gestatorial chair carriers', the commanders of the Swiss guards attached to the pope's person.

pl. 28. *Deliverance of St Peter*, ca. 1512–13, fresco, 660 cm base, Vatican City, Palazzi Vaticani, Stanza di Eliodoro.
The wall facing the *Mass of Bolsena* [pl. 27] features an episode from the Acts of the Apostles (12:4–18): the deliverance of St Peter from the dungeon by an angel. The cardinal title of Julius II was precisely the Roman church of San Pietro in Vincoli: on 23 June 1512 the pope had gone there on a pilgrimage to render thanks for the subsiding of the French menace. The inscription in the intrados of the window, with the year 1514, refers to the completion of the decoration of the room.

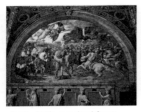

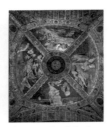

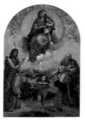

pl. 29. *Attila repulsed from Rome by Leo X*, ca. 1513–14, fresco, 750 cm base, Vatican City, Palazzi Vaticani, Stanza di Eliodoro.
The fresco, designed in the years of the pontificate of Julius II as attested by the copy of a preparatory drawing where the Della Rovere pope has the features of the protagonist, Leo the Great halting, near Mantua, the advance of the Huns on Rome, was later altered to glorify Leo X, who proceeds from the left surrounded by the miraculous apparition in Heaven of Sts Peter and Paul: this scene is the one that most explicitly treats the fundamental theme of all the frescoes of the room, the expulsion of the 'barbarians' from Italy.

pl. 30. *Vault of the Stanza di Eliodoro*, ca. 1513–14, fresco, 820 x 640 cm, Vatican City, Palazzi Vaticani.
The decoration of the vault of the Stanza di Eliodoro as well, like that of the Segnatura [pl. 17], began before Raphael's intervention: the *grisailles* of the intrados and spandrels are ascribable to Peruzzi's workshop, whereas in the archivolts the presence of Signorelli, Lotto and Bramantino (1508–9) can be discerned. Raphael, on completion of the work on the walls of the stanza, prepared drawings for the scenes of the vault, executed by his workshop with *Jacob's Ladder*, *Moses at the Burning Bush*, the *Sacrifice of Isaac* and *Jehovah appears to Noah*.

pl. 31. *The Prophet Isaiah* (with the *St Anne* by Andrea Sansovino), ca. 1513–14, fresco, 250 x 155 cm, Rome, Sant'Agostino, third pillar to the left of the main aisle.
The fresco was commissioned by the curial prelate Johann Goritz for his family altar: in the niche, prior to July 1512, was placed the *Madonna and Child with St Anne* by Andrea Sansovino, an example of the influence of Raphael's classicism on contemporary sculpture as well. It roused the enthusiasm of throngs of Roman poets, who on the saint's feast day affixed their poems here. The altar was reconstituted in January 1981.

pl. 32. *Foligno Madonna*, ca. 1511–12, oil on panel mounted on canvas, 308 x 194 cm, Vatican City, Pinacoteca Vaticana, inv. 329.
The work, at the behest of Sigismondo de' Conti, secretary of Julius II, was on the high altar of the church of Santa Maria in Aracoeli; removed to Foligno in 1565, it entered the Pinacoteca Vaticana in 1816. The fantastic landscape presents the motif (the meteorite that fell on the Conti house at Foligno without damaging it) that might have inspired the execution of the large ex voto, although recently several alternative hypotheses have been advanced (a comet, bearing the plague, or the cannonball that left Julius II unscathed).

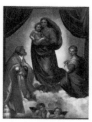

pl. 33. *Sistine Madonna*, 1512–13, oil on canvas, 269.5 x 201 cm, Dresden, Gemäldegalerie Alte Meister, inv. 93.
In all likelihood the work was commissioned by Julius II for the high altar of the Piacentine church of San Sisto. It was probably a mark of gratitude toward the Emilian city that had sided with the pope against the French, as well as an homage to Sixtus II: in this figure there may be an allusion to Sixtus IV, the patron's uncle. It was sold in 1754 to Augustus III of Saxony: removed to Moscow after World War II, it was returned in 1955 to the Gemäldegalerie of Dresden.

pl. 34. *La Velata*, ca. 1513, oil on canvas, 82 x 60.5 cm, Florence, Palazzo Pitti, Galleria Palatina, inv. 245.
The painting, mentioned by Vasari in the collection of the Florentine tradesman and banker Matteo Botti as the portrait of the woman Raphael loved, passed through bequests to the collection of the grand duke Cosimo II, entering Palazzo Pitti in 1622. Critical debate focused essentially on the identification of the young woman (Margherita Luti, known as the Fornarina?). Dating is the object of discussion: owing to stylistic connections with the *Sistine Madonna* [pl. 33], it is preferable to date it ca. 1513.

pl. 35. *Madonna of the Chair*, ca. 1513–14, oil on panel, 71 cm diameter, Florence, Palazzo Pitti, Galleria Palatina, inv. 151.
The work, executed for an unknown patron (perhaps cardinal Giovanni de' Medici), is documented at the Uffizi by 1635. Some identified it with the tondo cited in the Tribune of the Uffizi as of 1589, others, less convincingly, with the one that in 1609 was in the Palazzo Ducale of Urbino, removed to Florence in 1631 through the bequest of Vittoria Della Rovere. It entered the Pitti in 1698, and was placed in 1816 in the Saturn Room, next to other masterpieces by the artist. [pls. 10–11, 16, 24, 34].

pl. 36. *Chigi Chapel: mosaics of the dome*, 1516, Rome, Santa Maria del Popolo.
Toward 1513 Raphael designed the decoration of Agostino Chigi's mausoleum-chapel in Santa Maria del Popolo, contriving a new model for a mortuary chapel that combines the resources of architecture, sculpture (assigned to the Florentine Lorenzetto) and painting. The mosaics of the vault, based on cartoons by Raphael, bear the date 1516 and the signature of the Venetian Luigi de Pace; the altarpiece (dedicated to the *Nativity* or to the *Assumption of the Virgin*) was never completed.

pl. 37. *Ecstasy of St Cecilia* (with the frame by Giovanni Barili), ca. 1513–15, oil on panel mounted on canvas, 238 x 150 cm, Bologna, Pinacoteca Nazionale, inv. 577.
The altarpiece, already completed by August 1515, was commissioned by a Bolognese noblewoman, Elena Duglioli Dall'Olio, for a chapel of the church of San Giovanni in Monte; removed to Paris between 1796 and 1815, it then entered the Pinacoteca Nazionale of Bologna. The work constitutes a fundamental model of Raphael's language not only for the most classicising Emilian 16th century, but, by its ecstatic representation of the saint, for all Baroque devotional painting.

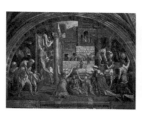

pl. 38. *Fire in the Borgo*, ca. 1514, fresco, 670 cm base, Vatican City, Palazzi Vaticani, Stanza dell'Incendio.
In the Stanza dell'Incendio, the pontiff's private dining-room, the decoration of which began in July 1514 with considerable assistance from collaborators, the subject of the first fresco is the miracle, told in the *Liber Pontificalis*, performed in A.D. 847, by Leo IV, who with the sign of the Cross succeeded in extinguishing the fire broken out in the Borgo district. With the painting Leo X wishes to underscore his political choice of peace, distancing himself from the ideological options of Julius II's pontificate.

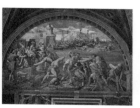

pl. 39. *Battle of Ostia*, ca. 1517, fresco, 770 cm base, Vatican City, Palazzi Vaticani, Stanza dell'Incendio.
The last fresco executed by Raphael and his assistants in the Stanza dell'Incendio is inspired once again by an event during the papacy of Leo IV: the battle in A.D. 849 at the mouth of the Tiber between the pontifical fleet and the Saracen pirates, routed thanks to a storm broken out by miracle. Here again the theme relates to the political situation, the crusade against the Turks planned by Leo X. The preparatory drawing given to Albrecht Dürer [fig. 5], dated 1515, allows to situate its conception during the early stages of the work in the room.

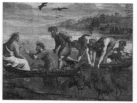

pl. 40. *Miraculous Draught of Fishes of St Peter*, 1515–16, tempera on paper glued on canvas, 319 x 399 cm, London, Victoria and Albert Museum.
At the end of 1514 Leo X commissioned Raphael for cartoons for a cycle of tapestries that was to adorn the walls of the Sistine Chapel (woven in Brussels): the first known payment is dated 15 June 1515, a second one 20 December 1516. Seven tapestries were hung in the Sistine Chapel on 26 December 1519; the three others arrived toward 1521; the remaining cartoons were purchased in 1623 for Charles I of England, passing in 1865 to the London South Kensington Museum (present-day Victoria and Albert).

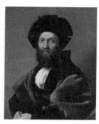

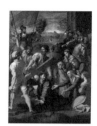

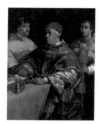

pl. 41. *Portrait of Baldassar Castiglione*, ca. 1514–15, oil on canvas mounted on a panel, 82 x 67 cm, Paris, Musée du Louvre, inv. 611.
The work, probably executed in the winter of 1514–15 when Castiglione was the duke of Urbino's ambassador at the pontifical court, was conveyed in 1516 to Mantua to his wife, Ippolita Torelli, invited, in an elegy datable to around 1519, to draw solace from the portrait during her consort's absences. In 1661, after passing through several collections (Francesco Maria Della Rovere, Lucas van Uffelen, Alfonso Lopez, Cardinal Mazarin), it entered the collections of Louis XIV; it was exhibited at the Louvre in 1793.

pl. 42. *Lo Spasimo* or *Christ Falls on the Way to Calvary*, ca. 1515–16, oil on panel mounted on canvas, 318 x 229 cm, Madrid, Museo Nacional del Prado, inv. 298.
The painting, commissioned by the jurist Giacomo Basilicò for the Palermitan monastery of Santa Maria dello Spasimo, was nearly lost in a shipwreck: recovered in Genoa, it was sent to Sicily and placed in the elegant marble aedicule by Antonello Gagini. Purchased for King Philip IV, it has been in Madrid since 1661. Signed on a stone in the foreground ("RAPHAEL URBINAS") and derived from a woodcut by Dürer, it was executed with the collaboration of the workshop (notably Giulio Romano and Penni).

pl. 43. *Vatican Logge: general view*, ca. 1517–19, Vatican City, Palazzi Vaticani.
The decoration of the Logge (thirteen bays, each with four Biblical scenes) was carried out for a large part by the workshop (Giulio Romano, Giovan Francesco Penni, Tommaso Vincidor, Vincenzo Tamagni, Polidoro da Caravaggio, Giovanni da Udine, Perino del Vaga, Pellegrino da Modena). At the behest of Leo X, the grotesques and stuccoes *all'antica* were meant to accompany a group of classical sculptures: the Logge, open and overlooking the city, were to become a privileged place for appreciating the rebirth of ancient Rome.

pl. 44. *Portrait of Leo X with cardinals Giulio de' Medici and Luigi de' Rossi*, 1518, oil on panel, 155 x 119 cm, Florence, Galleria degli Uffizi, inv. 40.
Sent to Florence in September 1518 for the nuptials of Lorenzo de' Medici with Madeleine de la Tour d'Auvergne, a relative of François I of France, the portrait has political relevance, glorifying the Medici family as patrons of culture in the person of the pope busy examining an illuminated Bible. The figures of the cardinals were introduced later (probably by a collaborator). The work has always been in Florence: in the Tribune of the Uffizi in 1589, at the Pitti as of 1697, in 1952 it returned to the Uffizi.

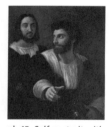

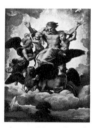

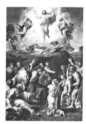

pl. 45. *Self-portrait with a Friend*, ca. 1519, oil on canvas, 99 x 83 cm, Paris, Musée du Louvre, inv. 614.
The work, one of Raphael's last, shows the countenance of the artist at the end of his short life. We do not know the identity of the figure in the foreground, the so-called 'fencing master', who turns to look at his friend with one hand on the hilt of the sword, while the other points its forefinger at the beholder (recently the names Giovanni Battista Branconio dell'Aquila and Giulio Romano have been advanced). The painting is documented in France in the 17th century; it entered the Louvre in 1792.

pl. 46. *Mercury descends from the sky to announce the Contest of Psyche*, ca. 1517–18, fresco, Rome, Villa Farnesina, Loggia di Psiche.
The decoration of the loggia was completed in January 1519, in view of the marriage of Agostino Chigi with Francesca Ordeaschi, celebrated on 28 August; for a large part executed by the workshop (especially by Giulio Romano and Giovanni da Udine), it was never fully completed with the episodes in the lunettes and on the walls. Apuleius's fable was probably chosen to hint to the bond between the Sienese banker, who already possessed various works by Raphael [pls. 25 and 36], and the young Venetian girl.

pl. 47. *Vision of Ezekiel*, ca. 1518, oil on panel, 40.7 x 29.5 cm, Florence, Palazzo Pitti, Galleria Palatina, inv. 174.
The work, executed for the Bolognese Vincenzo Ercolani, was purchased between 1574 and 1579 by Francesco I de' Medici. In 1589 it was in the Tribune of the Uffizi, in 1697 it passed to Palazzo Pitti and, after being taken to Paris in 1799, in 1816 to the Galleria Palatina.
The vision of Ezekiel (also recently defined as the vision of St John at Patmos) is interpreted in light of the archaeological studies that occupied Raphael in his last years: as Vasari observed, the figure of the Lord is designed "in the fashion of Jupiter", deriving from a famous antique sarcophagus.

pl. 48. *Transfiguration*, ca. 1518–20, oil on panel, 410 x 279 cm, Vatican City, Pinacoteca Vaticana, inv. 333.
Commissioned by Cardinal Giulio de' Medici as a gift for the cathedral of Narbonne, the city of which he was bishop, together with the *Raising of Lazarus* by Sebastiano del Piombo (National Gallery, London), in July 1518 the panel was still not begun, but then was almost completed at the artist's death (April 1520). Exhibited in the Palazzo della Cancelleria and then given by the patron in 1523, after his ascent to the papal throne, to the church of San Pietro in Montorio, it entered the Pinacoteca Vaticana in 1817.

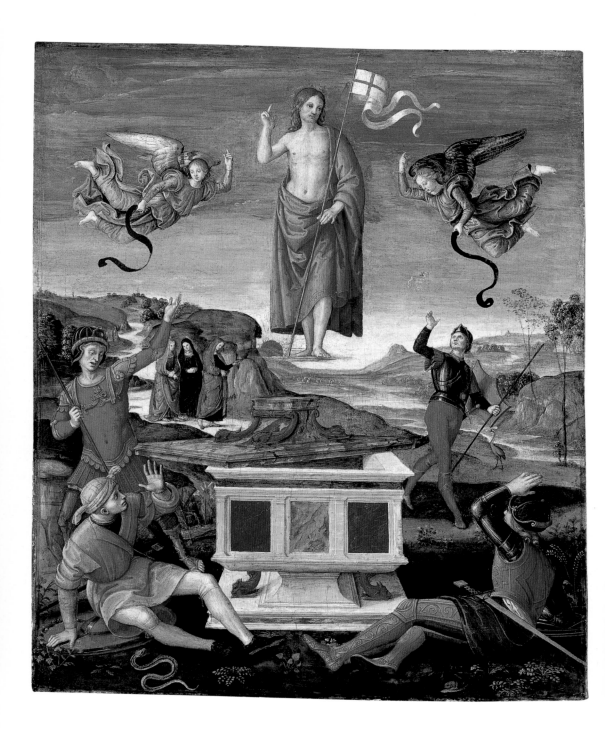

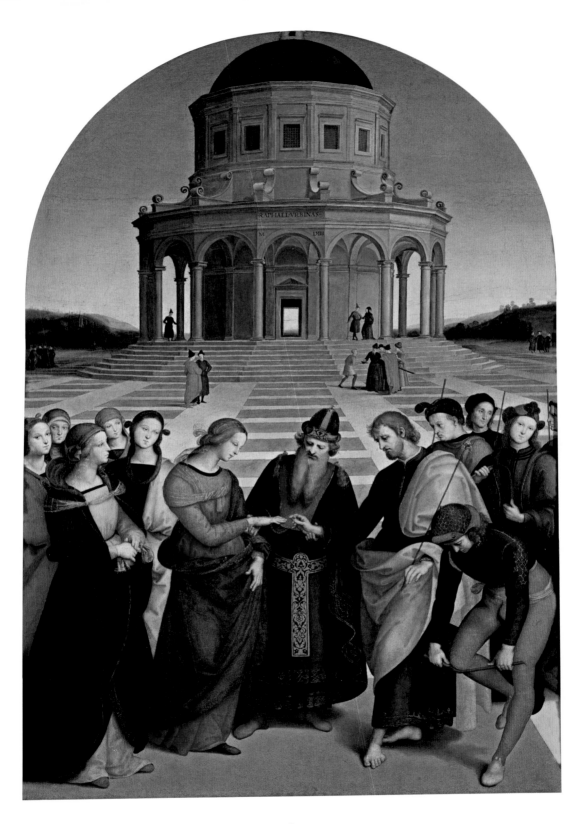

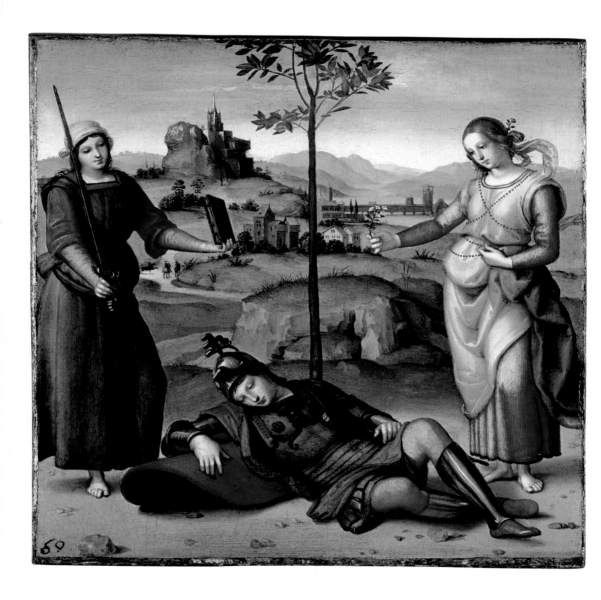

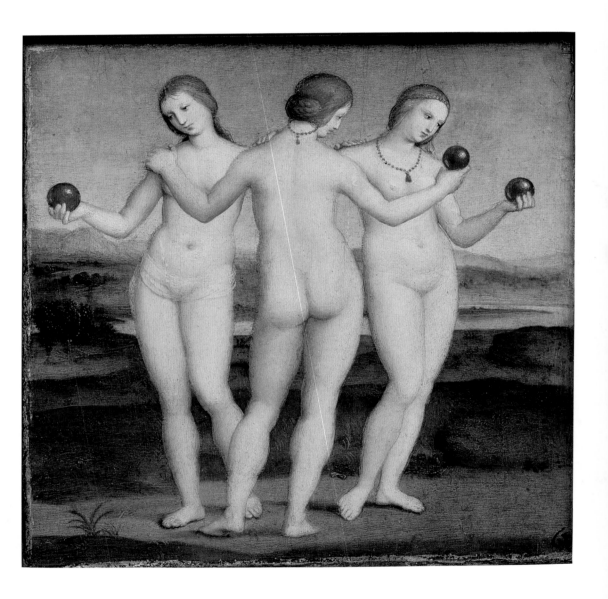

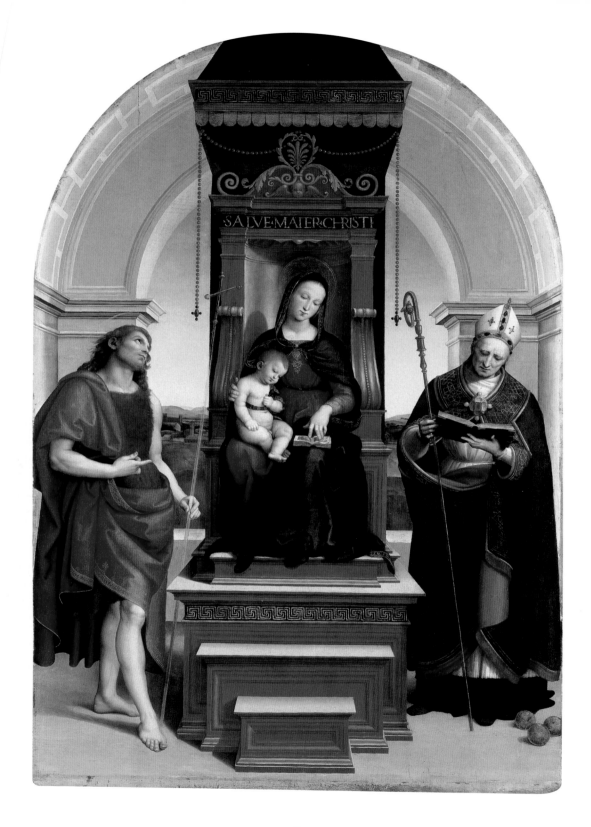

SALVE·MATER·CHRISTI

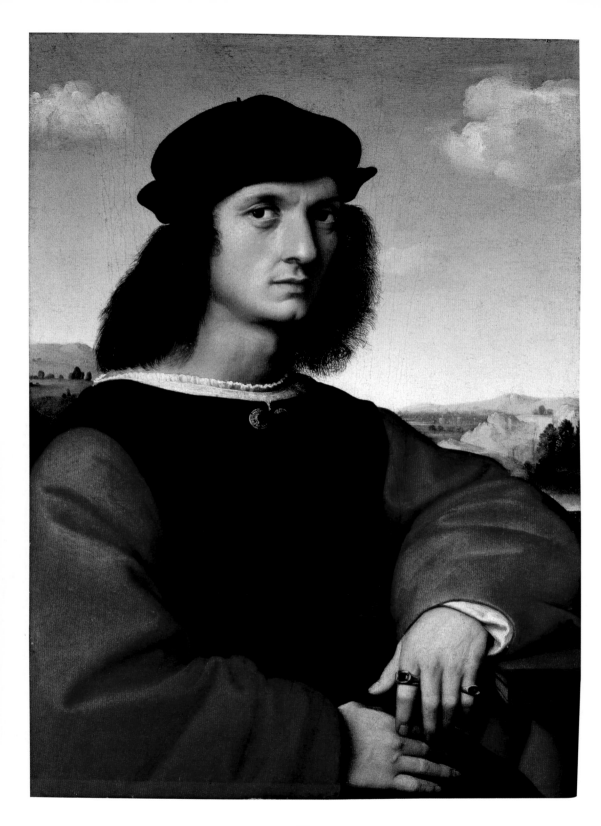

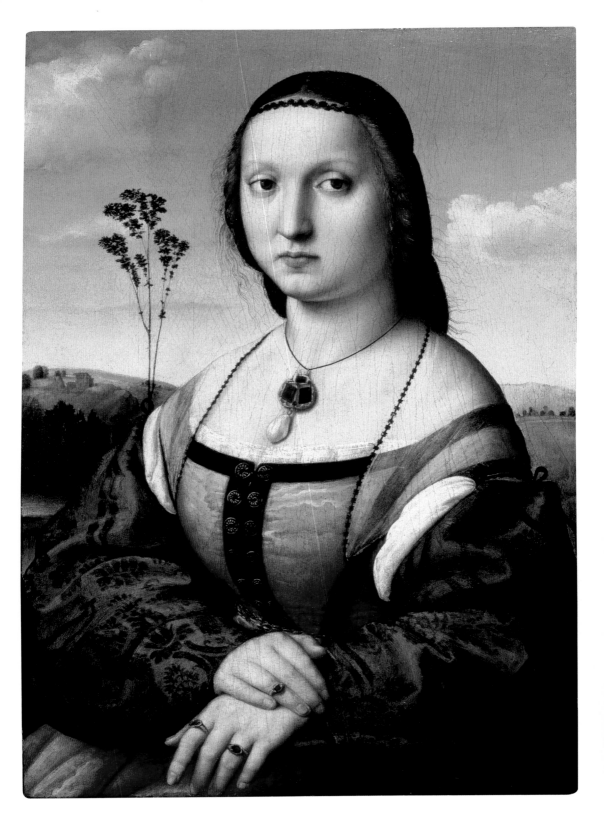

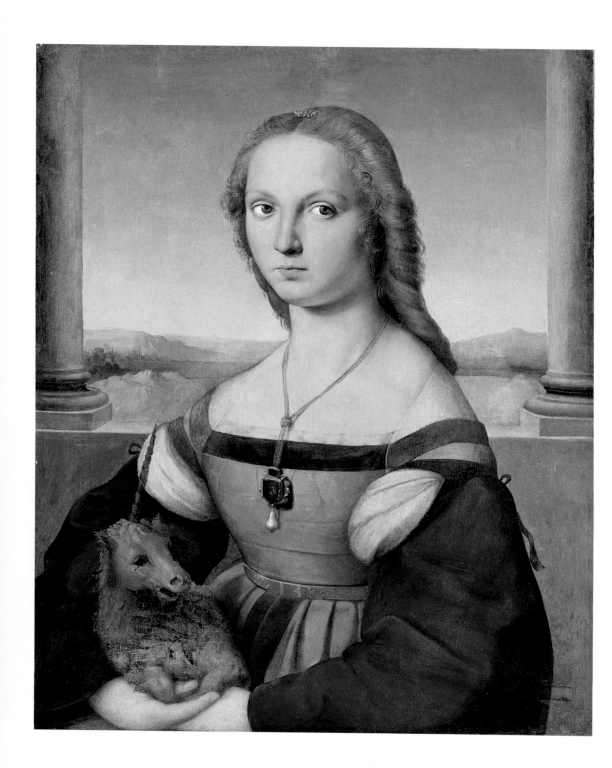

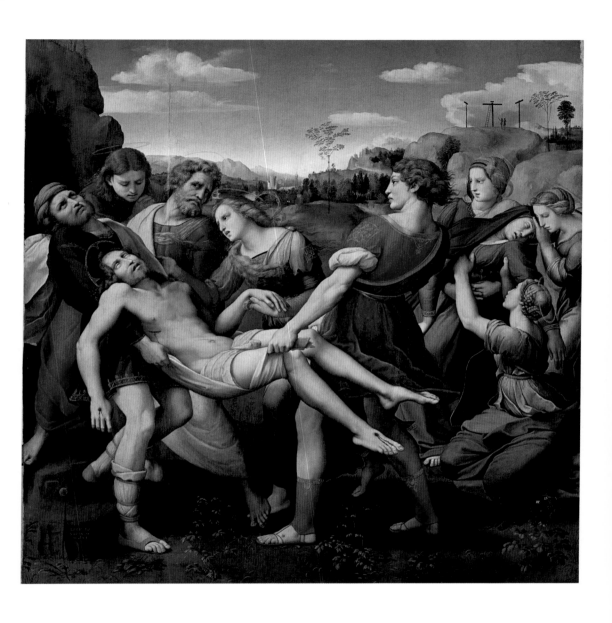

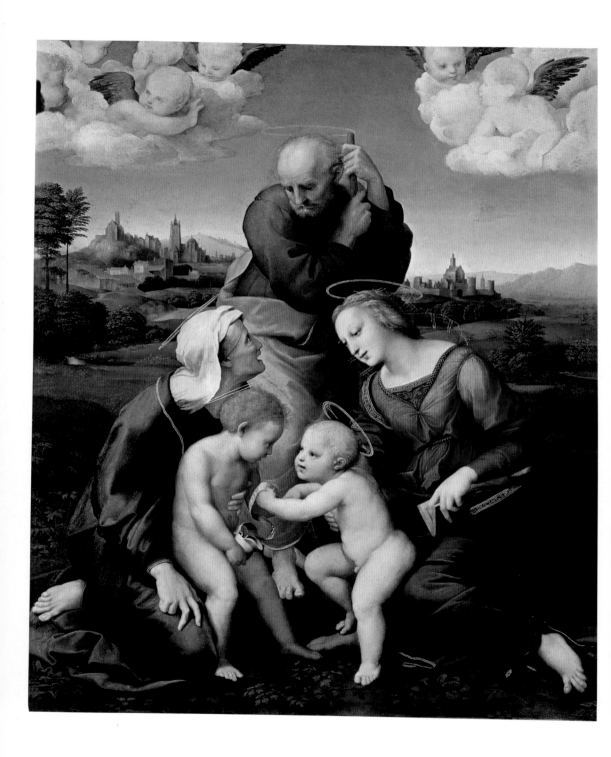

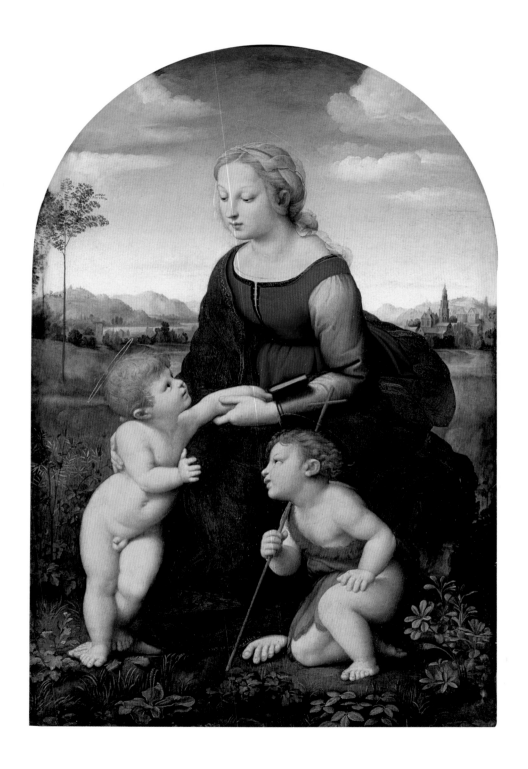

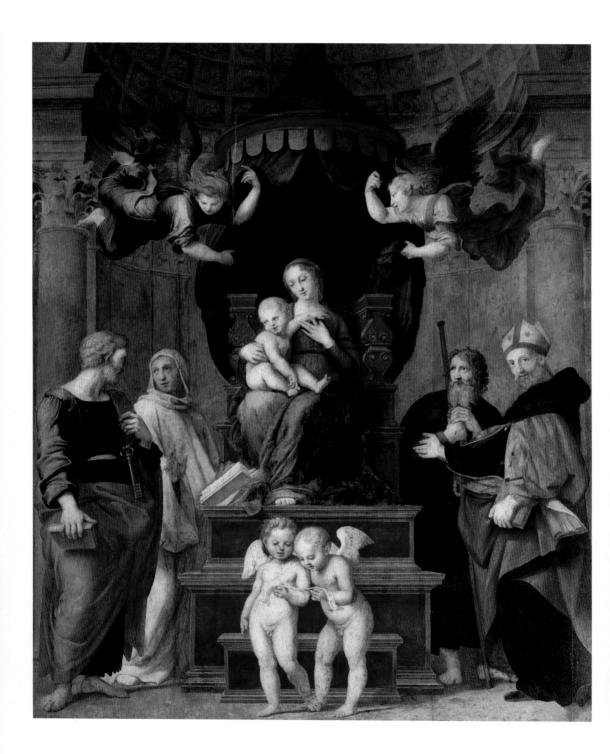

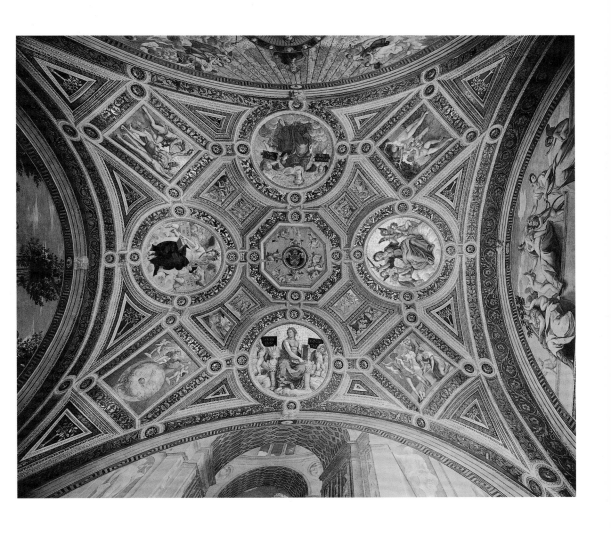

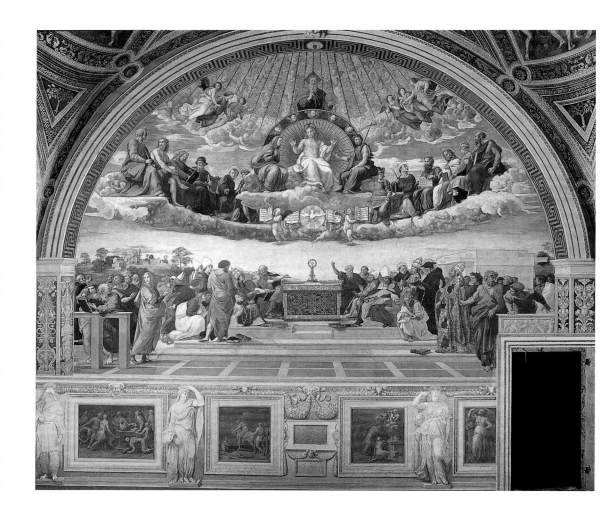

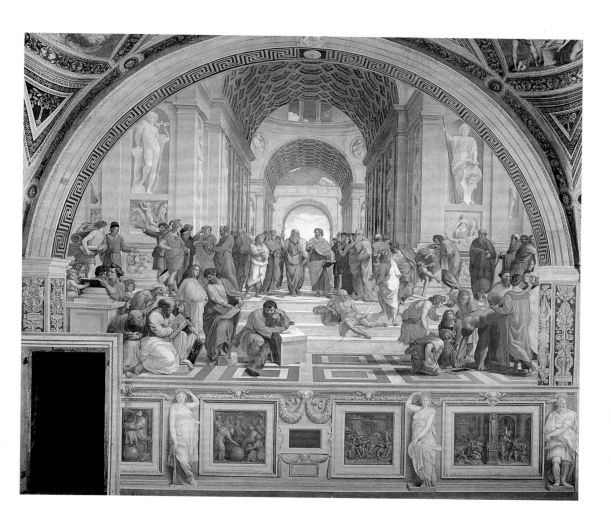

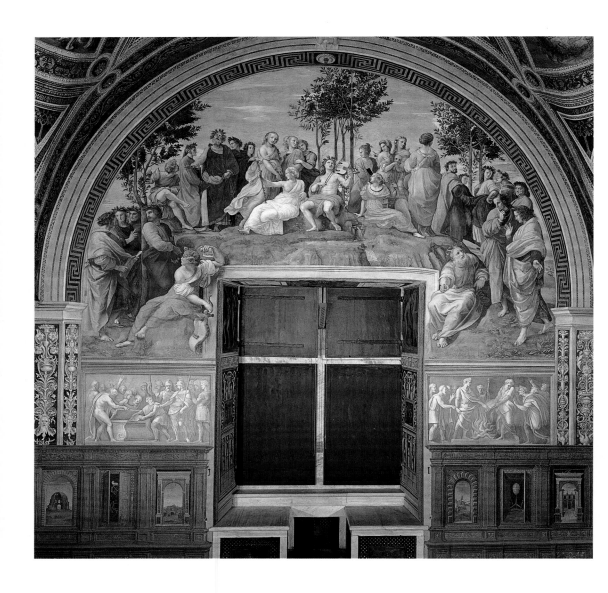

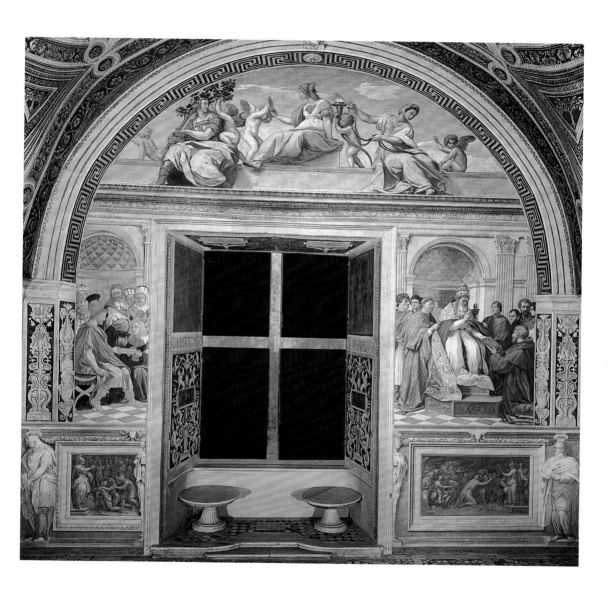

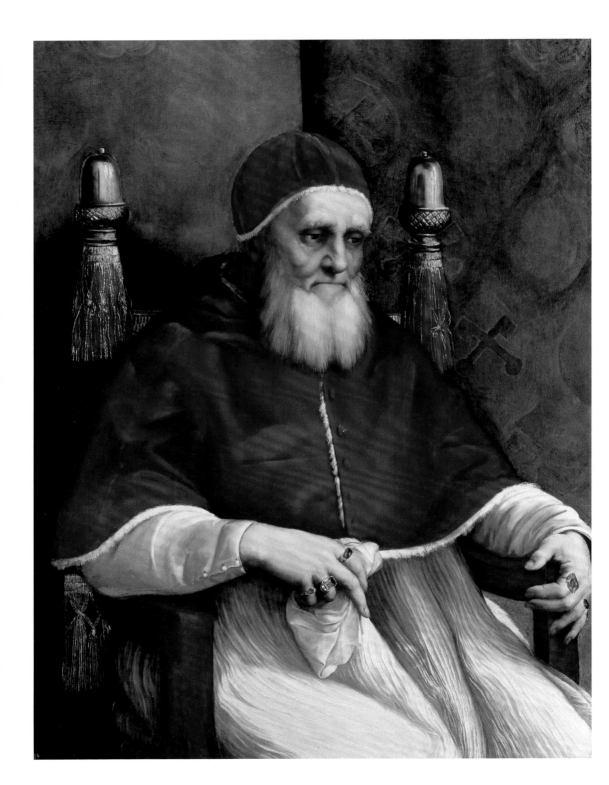

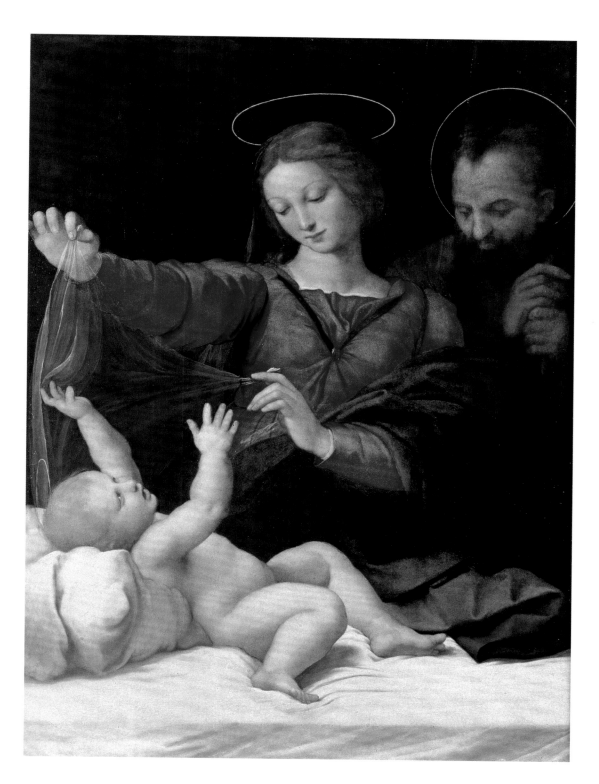

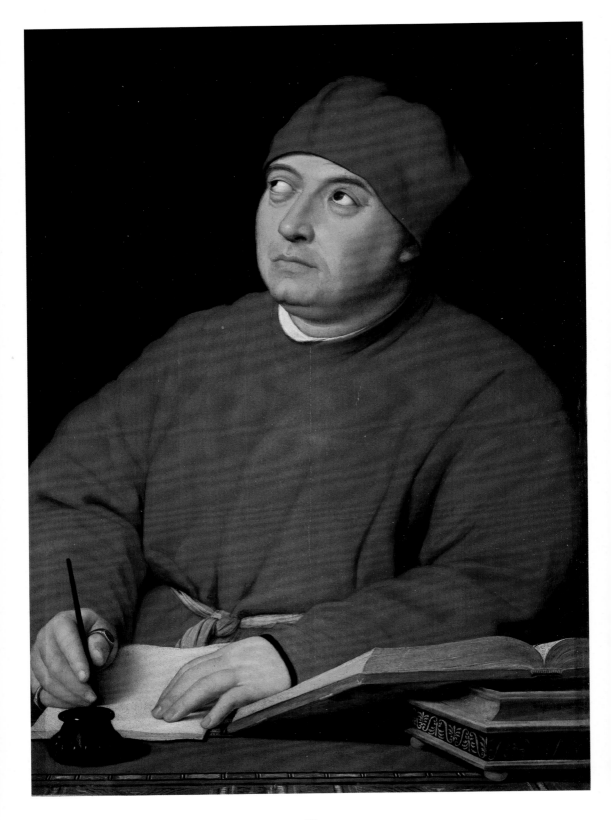

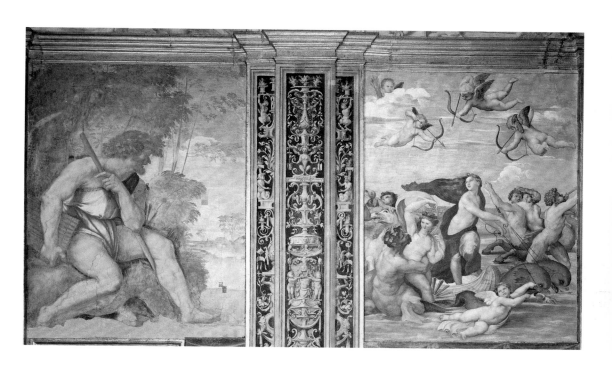

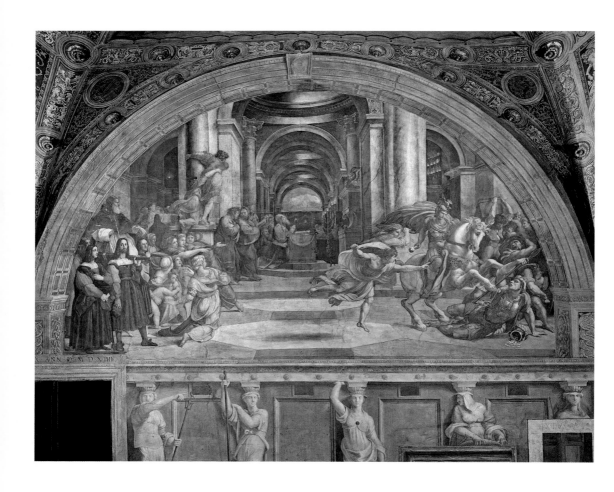

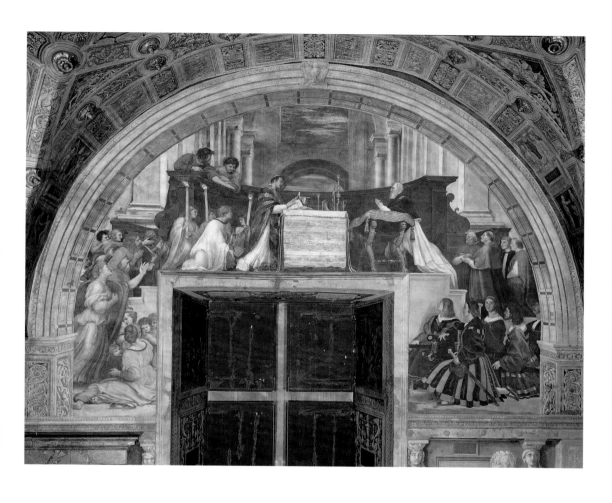

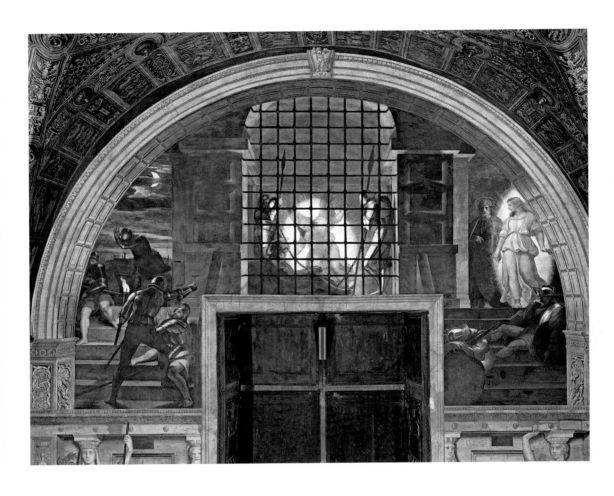

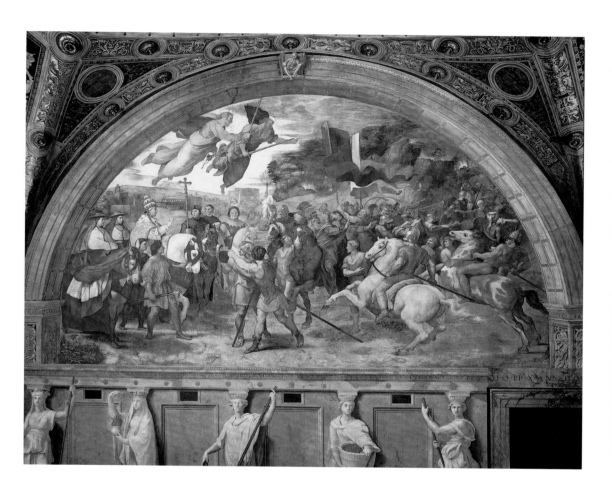

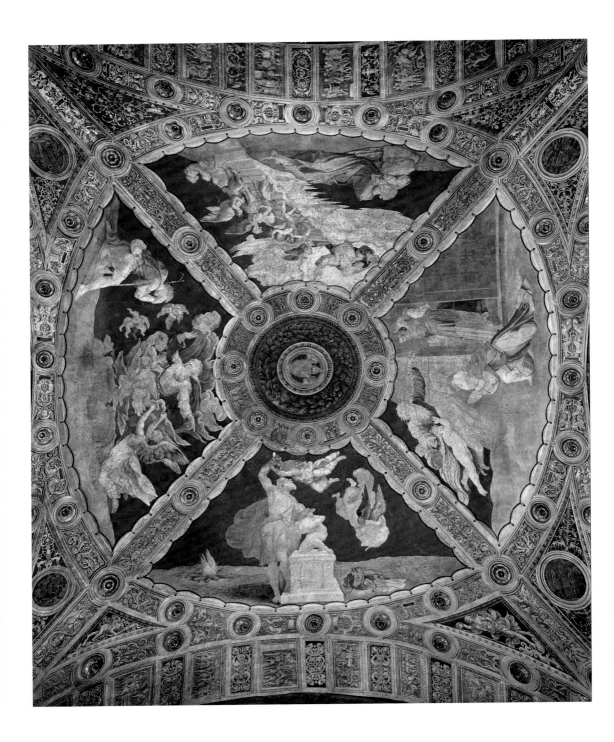

31

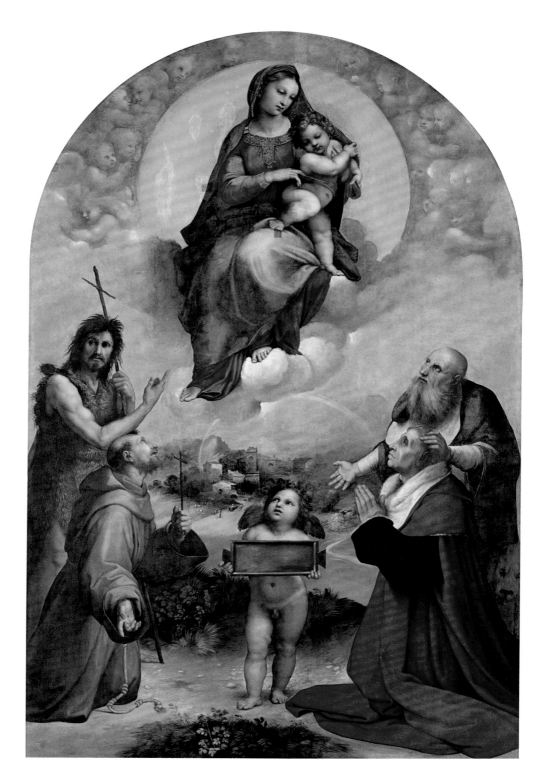

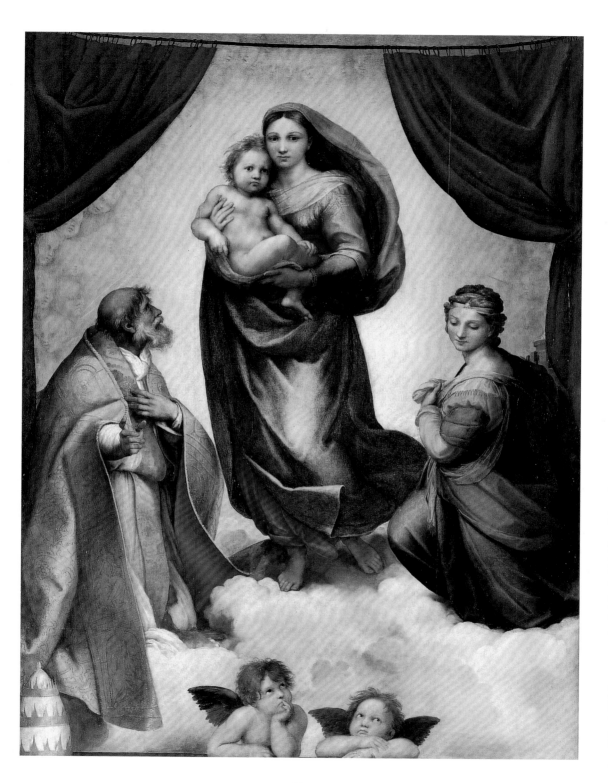

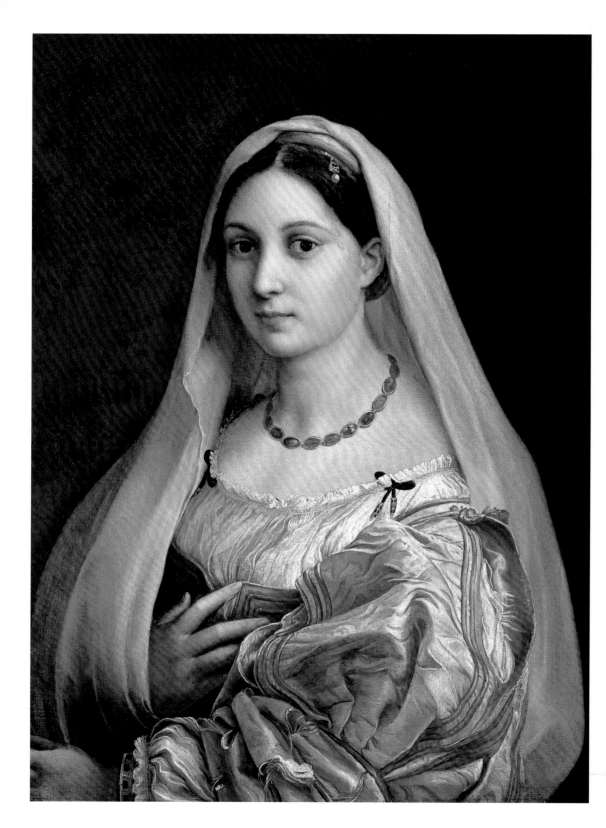

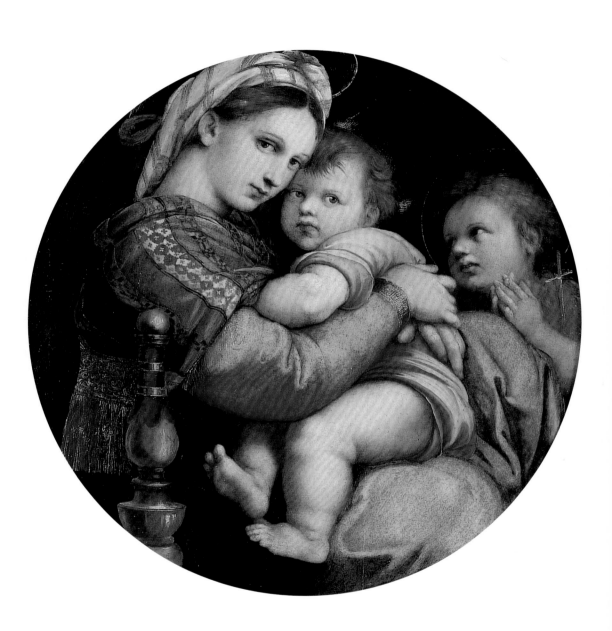

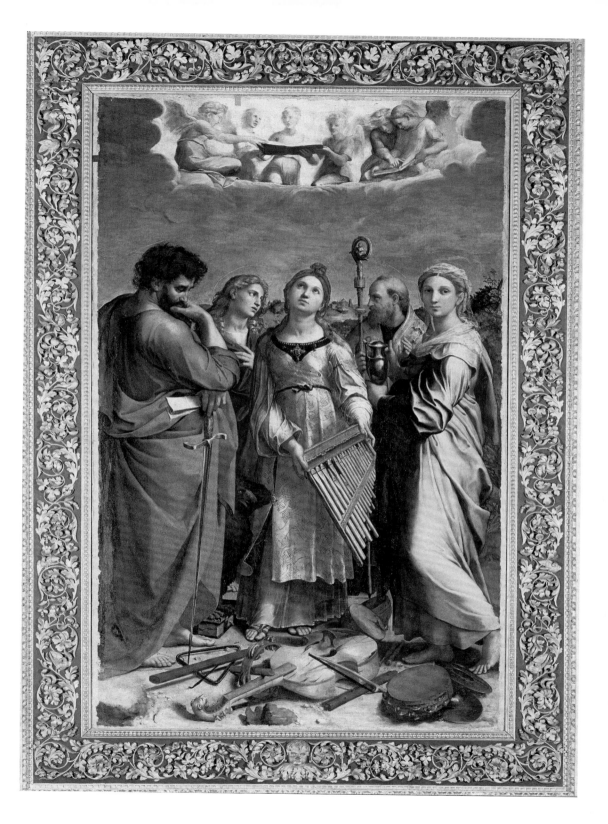

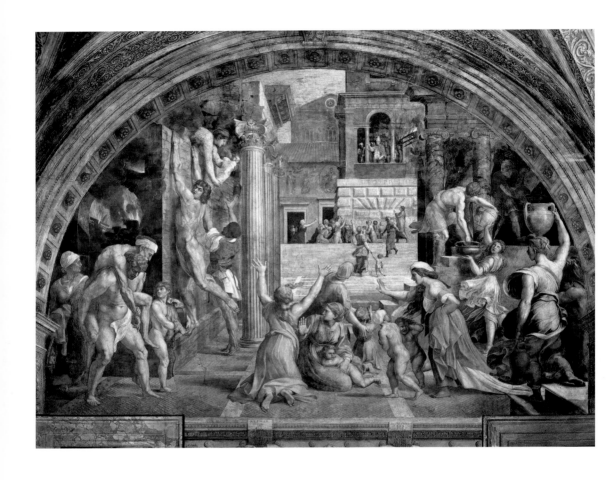

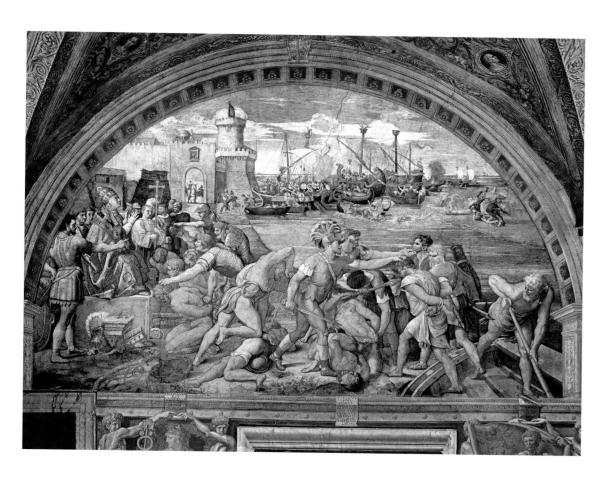

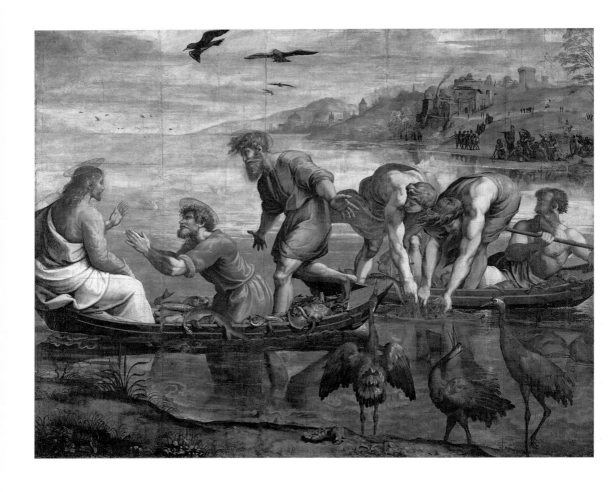

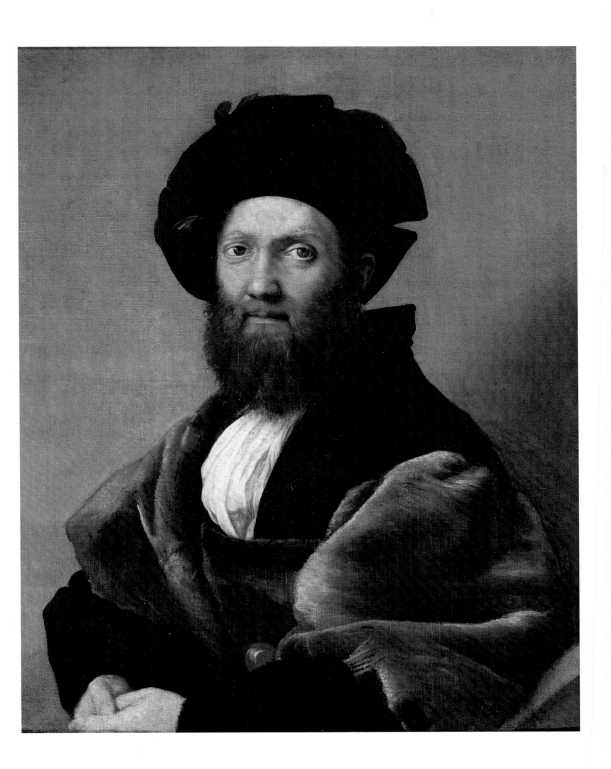

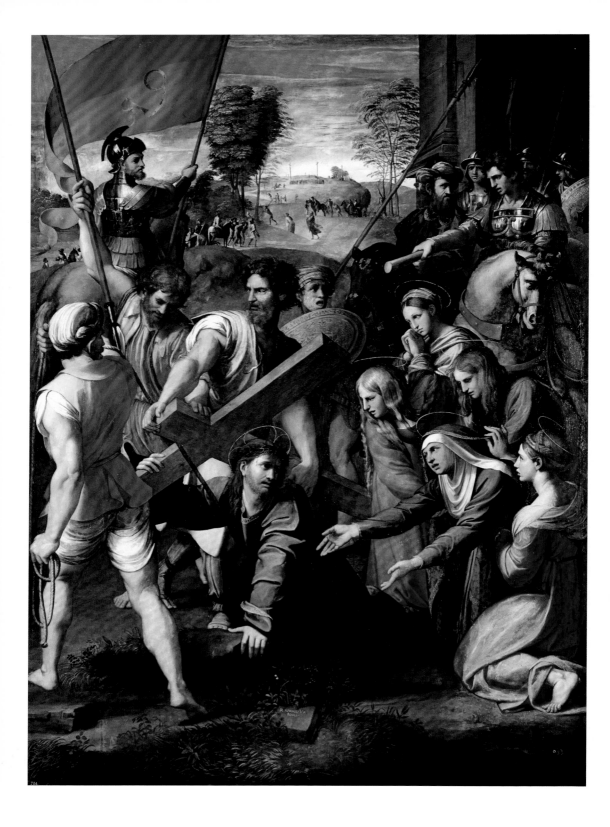

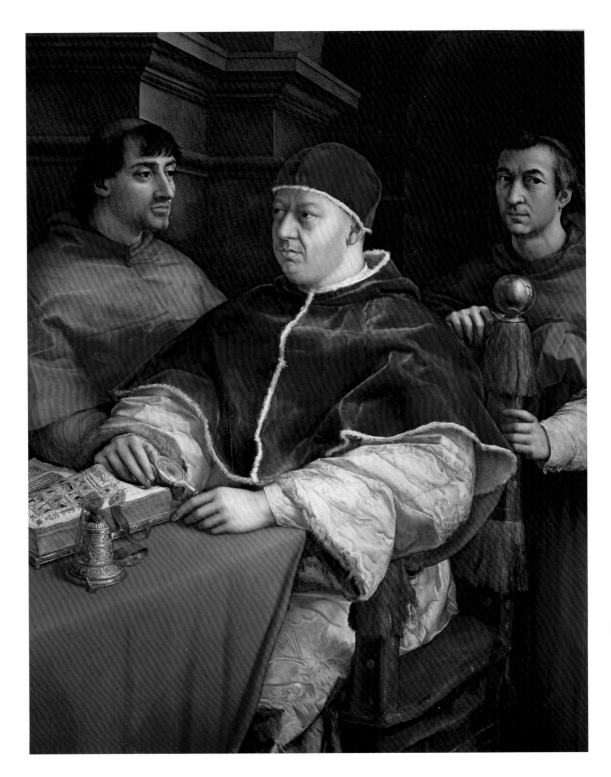

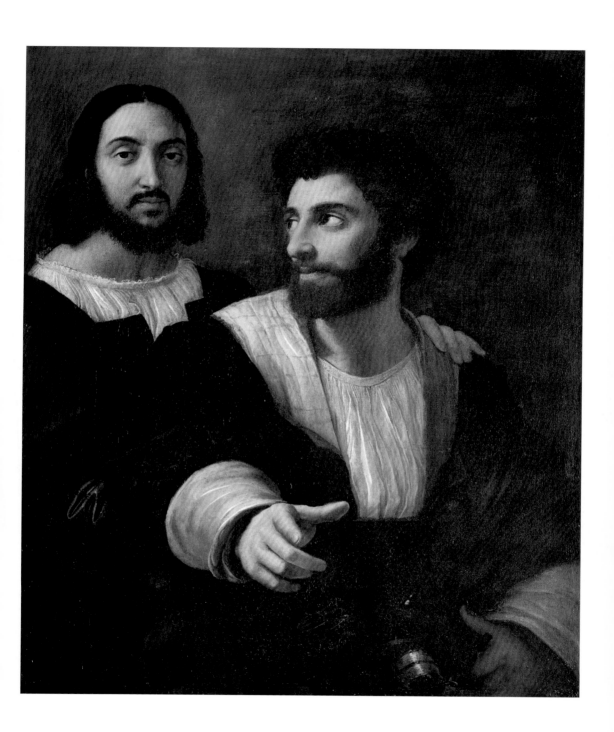

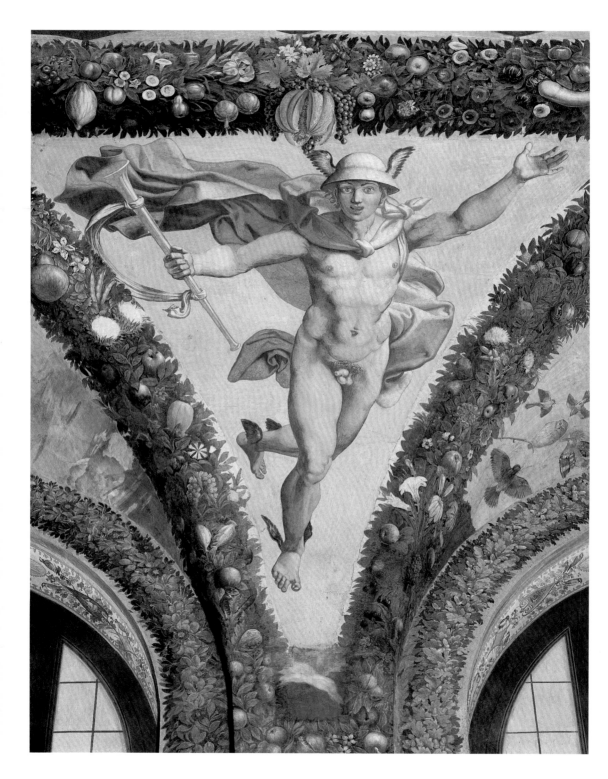

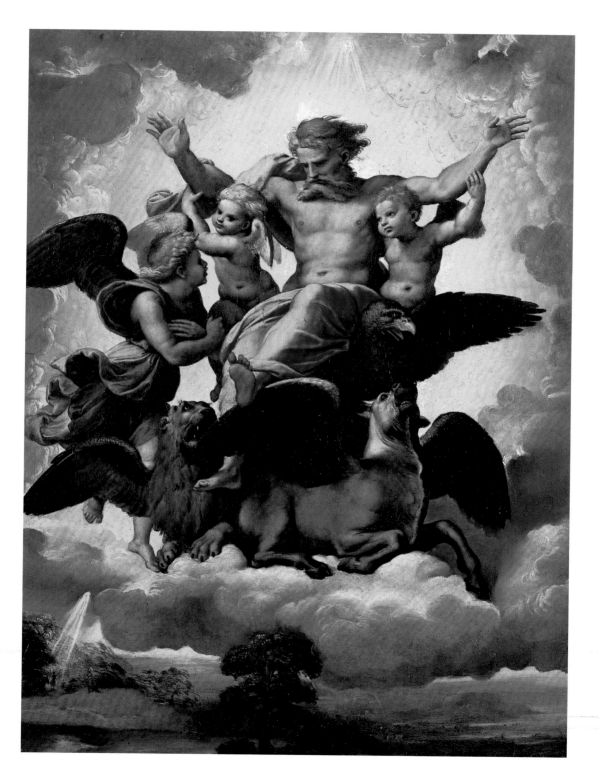

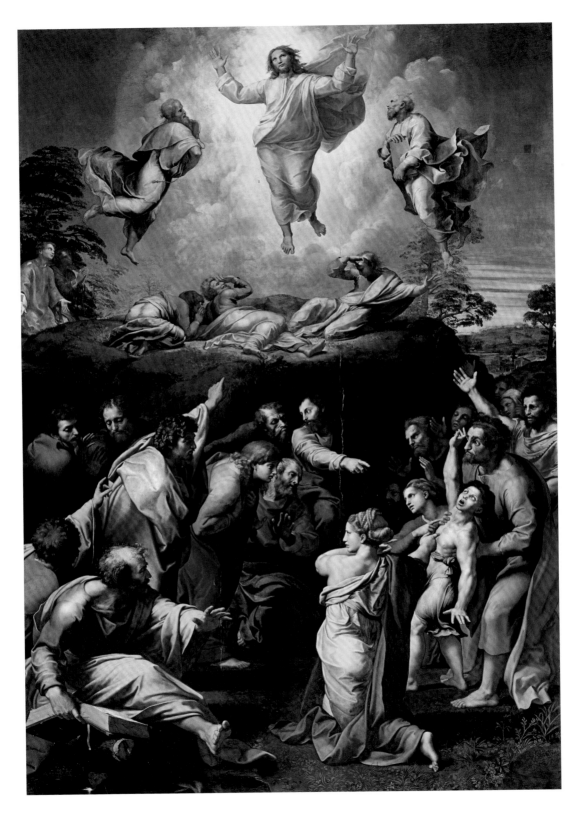

APPENDICES

CHRONOLOGY

1483

The day of Raphael's birth is still uncertain: either 28 March or 6 April. The second date, suggested by the epitaph Pietro Bembo (or Tebaldeo) wrote for the painter's tomb in the Pantheon in Rome ("V[ixit] A[nnos] XXXVII INTERGER INTEGROS QUO DIE NATUS EST EO ESSE DESIIT VIII ID[ibus] APRIL[is] MDXX"), appears more likely. Raphael was born at Urbino. His father, Giovanni Santi, was a painter connected with the court of Montefeltro.

1491

In early October, when Raphael was eight years old, his mother Magia di Battista Ciarla passed away, probably while giving birth to a daughter, who died at the end of the same month.

1494

Giovanni Santi's will, drawn up in three versions between 26 and 29 July, appointed as residuary legatees his son Raphael and his brother Bartomoleo di Sante: it is worth mentioning that the witnesses include the Milanese sculptor and architect Ambrogio Barocci, active in the yard of the Palazzo Ducale of Urbino, and the painter Evangelista da Pian di Meleto, Raphael's father's main pupil and collaborator. Giovanni Santi died on 1 August.

In the ensuing years, legal wrangling over the inheritance would oppose Bartomoleo di Sante and Raphael to Bernardina di Pietro Parte, Giovanni Santi's second wife.

1500

On 10 December Raphael, already defined "magister" at the age of seventeen, and Evangelista da Pian di Meleto, who must have been around forty, sign a contract with Andrea Baronci, an important personality of Città di Castello (a tradesman who was prior several times between 1466 and 1502), for the execution of an altarpiece for the family chapel in the church of Sant'Agostino [fig. 1].

1501

On 13 September the two painters receive from Andrea Baronci the balance of sixteen ducats for the completion of the work, identifiable with the *Coronation of St Nicholas of Tolentino* [pl. 1].

1502

Toward this year Raphael was in contact with Pinturicchio, collaborating at Siena in designing the frescoes for the Piccolomini Library in the cathedral [fig. 3], executing the predella for an untraced altarpiece formerly in the church of San Francesco, and drawings for the *Coronation of the Virgin* painted by Pinturicchio and Giovanni Battista Caporali for Santa Maria della Pietà at Umbertide (Rome, Pinacoteca Vaticana): the São Paulo *Resurrection of Christ* [pl. 2] can be considered figurative evidence of young Raphael's "Pinturicchio period".

1503

In January and March Raphael is document ed at Perugia. The year figures in the inscription carved on the altar of Domenico de' Gavari (a tradesman and banker who had been prior several times and was in relations with the Baronci family) in the church of San Domenico at Città di Castello, decorated by the Mond *Crucifixion* of the London National Gallery [pl. 3], a work Raphael signed ("RAPHAEL URBINAS P[inxit]") was in all likelihood executed around that date.

1504

The year figures with the signature in the Brera *Nuptials of the Virgin* [pl. 5], executed on a commission from Filippo di Lodovico Albizzini (a tradesman and notary who had been prior several times and was in relations with the Gavari family) for the San Giuseppe chapel in the church of San Francesco at Città di Castello. In January Raphael is mentioned in a Perugia notarial document as "residing at Perugia". The date of the artist's transfer to Florence is not certain, since the famous letter of recommendation to Pier Soderini from Giovanna Feltria Della Rovere dated 1 October 1504, first published by Giovanni Gaetano Botteri in 1754, is probably an eighteenth-century fake.

1505

On 12 December Raphael, "magister", signs a contract to execute in collaboration with Berto di Giovanni an altarpiece for the convent church of Santa Maria di Monteluce, outside the walls of Perugia: the *Coronation of the Virgin* (Pinacoteca Vaticana), not completed until 1525, was probably inspired by the painting on the same subject Domenico Ghirlandaio created in 1486 for Narni, rather than by the *Coronation* executed by Raphael himself in the preceding years for the Perugian church of San Francesco [pl. 4].

The year 1505 we read under the *Trinity and Saints* frescoed by Raphael in the Perugian church of San Severo [pl. 9] appears in an inscription that was probably added by Perugino in 1521 when the work was completed with the six *Saints* of the lower register.

1505 OR 1506

The date 1505 (or 1506?) appears on both the London Ansidei *Madonna* [pl. 8], executed for the church of San Fiorenzo at Perugia for a family of tradesmen, and the Vienna *Madonna of the Meadow* (or *Belvedere Madonna*), painted perhaps for the Florentine Taddeo Taddei.

1506

In the draft of a poem in December Baldassar Castiglione, from London, directly addresses the portrait of Elisabetta Gonzaga, which belonged to him, painted by Raphael.

1507

In October Raphael is documented at Urbino: he is working on a *Christ in the Garden of Olives* for duchess Elisabetta Gonzaga. The same year he signs and dates the *Entombment* for the Baglioni chapel in the Perugia church of San Francesco al Prato [pl. 13] and the Prado *Holy Family of the Lamb*. 1507 is also the date figuring on the verso of a lost miniature portrait of his father Giovanni Santi (in an inscription testifying that in 1520 this painting belonged to the collection of the Florentine banker Bindo Altoviti).

1508

On 21 April Raphael writes his maternal uncle Simone Ciarla at Urbino deploring the death of duke Guidobaldo, recommending he fittingly honour Taddeo Taddei's visit, reflecting on the price of the *Madonna del Baldacchino* [pl. 16], requesting, via the sculptor Giovan Cristoforo Romano, a letter of introduction from Francesco Maria Della Rovere to the gonfalonier Pier Soderini for "a certain room to work on". Between May and July (of the same year) two payments to a "Raffaello di Giovanni painter" (whom it seems plausible to identify with Raffaello Sanzio) document the gilding of a metal wreath to cover the nudity of Michelangelo's *David* and an important *Madonna and Child* for the Sala dell'Udienza dei Nove in Palazzo Vecchio. The date 1508 figures probably on the Louvre *Belle Jardinière* [pl. 15] and the Cowper *Large Madonna* of Washington. The time of Raphael's removal to Rome is not known with certainty: the famous letter from the artist dated 5 September 1508 from Rome to Francesco Francia at Bologna has been convincingly rated a 17th-century fake produced by Carlo Cesare Malvasia.

1509

The first payment to Raphael for the work in the Stanza della Segnatura is dated 13 January: 100 ducats "ad bonum comptum picture camere de medio eiusdem Santitatis testudinate".

On 3 June Francesco Albertini at the close of the manuscript of the *Opusculum de mirabilis novae et veteris Urbis Romae* [published in Rome on 4 February of the following year) mentions the "pictores concertantes" working in Julius II's new Vatican rooms, not yet distinguishing Raphael's name. Several of Raphael's poetic essays date to around 1509: five sonnets in the style of Petrarch on a series of drawings related to the *Disputation over the Most Holy Sacrament* [pl. 18] and the *Parnassus* [pl. 20].

1510

On 10 November the Sienese banker Agostino Chigi pays 25 ducats to the Perugian goldsmith Cesarino Rossetti for two bronze tondi "secundum ordinem et formam eidem dandam per magistrum Raphaelem Johannes Sancti de Urbino": although the identification of these works is still not certain the document offers the first clear evidence of Raphael's connection with the banker.

1511

On 12 July Gian Francesco Grossi, known as Grossino, writes from Rome to Isabella d'Este at Mantua that "the pope [...] again in the Palace has had two rooms painted by a certain Rafaello da Urbino, who has great fame as an excellent painter in Rome". On 16 August Grossino, after referring to Michelangelo's Sistine vault as being the work of Raphael (thus anticipating the mistake in Johannes Fichard's *Italia* in 1536), reports to Isabella that Pope Julius II had expressed the wish that her son, Federico Gonzaga, a hostage at the papal court for the past year, be portrayed by the Urbino artist "in a room that he is having painted in the Palace, where there is also His Holiness from life with a beard" (in this case it is not clear whether the reference is to the Stanza della Segnatura or di Eliodoro). On 4 October Raphael, "pupil of Giovanni da Urbino", is appointed by Julius II "scriptor brevium apostolicorum", providing him adequate steady financial support. In November of the same year he is in touch with the Sienese architect and painter Baldassare Peruzzi. Two inscriptions in the Stanza della Segnatura, in the intrados of the windows of the walls featuring *Parnassus* [pl. 20] and *Justice* [pl. 21], cite the eighth year of the pontificate of Julius II (that is, the period between 1 January and 25 November 1511).

1512

On 24 May Isabella d'Este writes to Matteo Ippolito in Rome asking him to have Raphael paint a portrait of her son Federico Gonzaga "half-length in armour": in January the following year the painting was begun, but interrupted in February because of Julius II's death (but the portrait will be completed, as evidenced by a letter of 1 January 1521 from Baldassar Castiglione to Federico Gonzaga, and therefore sent to Mantua in February of that year). On 11 July Alfonso d'Este, duke of Ferrara, visits in the Vatican the Borgia Apartments decorated by Pinturicchio, and meets Michelangelo on the scaffolding of the Sistine Chapel, but avoids going to the rooms that "Raphael is painting", having had "great reserves over going into the room where the Pope sleeps". An inscription in the Stanza di Eliodoro, in the intrados of the window of the wall featuring the *Mass of Bolsena* [pl. 27], cites the ninth year of the pontificate of Julius II (that is, the period between 1 January and 25 November 1512).

1513

On 7 July Raphael is paid 50 ducats by the papal treasurer for an unspecified commission. 12 September his *Portrait of Julius II* [pl. 22] is shown for eight days on the altar of Santa Maria del Popolo, Rome: as Marin Sanudo writes, "all Rome is running to see it; it is like a jubilee, so many flock there".

1514

An inscription in the Stanza di Eliodoro, in the intrados of the window of the wall featuring the *Deliverance of St Peter* [pl. 28], cites the second year of the pontificate of Leo X (that is, the period between 19 March and 31 December 1514). In June Raffaele Riario, cardinal of San Giorgio, has Raphael make copies of the portraits of Luigi and Ferrante Gonzaga executed by Francesco Bonsignori for Francesco Gonzaga. On 1 July Raphael writes to his uncle Simone Ciarla at Urbino telling him about the profitable new commissions assigned him by the pontiff: the responsibility of the Fabbrica di San Pietro (the construction of St Peter's) in collaboration with Fra Giocondo, since Bramante had died 11 or 12 March, and the start of a new room (that will be identified as the

Stanza dell'Incendio: the first two will be paid for before 1 August). Another urgent problem is that of marriage. Raphael in fact tells his uncle that Cardinal Bernardo Dovizi da Bibbiena offered him his own niece Maria (or Marietta) in marriage, who was to die before the artist. According to Vasari, Raphael would have hesitated to accept this prestigious marriage because of the chance, hinted at by the pope, of becoming a cardinal. On 1 August Raphael is appointed by Leo X architect of the Fabbrica di San Pietro (an assignment already obtained *de facto* by 1 April, and now officially confirmed after the presentation of a proper architectural model for the new basilica). On 4 December Alfonso I d'Este writes his brother, Cardinal Ippolito, in Rome to pay Raphael 50 ducats as partial payment for an *Indian Triumph of Bacchus* for the 'camerino d'alabastro' (the commission might have been assigned the year before when the duke of Ferrara, in Rome for the ceremonies following the election of Leo X, devoted himself exclusively to "having paintings painted and seeing antiques").

1515

On 15 June Raphael receives the first known payment for the cartoons of the Sistine Chapel tapestries. The same month he is engaged in executing a "little painting" for Isabella d'Este: in November through Baldassar Castiglione the marquise of Mantua sends the artist a canvas with specifications of dimensions and source of light, but by the end of 1519 the canvas was still not completed. In the *Leggenda anonima di Elena Duglioli*, a hagiographic text written toward 1530, "la bella Cecilia", meaning the entire chapel built in the Bolognese church of San Giovanni in Monte complete with its main ornament, Raphael's altarpiece [pl. 37], is said to be "completed" already "in the month of August 1515". On 27 August Leo X appoints Raphael "praefectus" of all the marbles and plaques unearthed in Rome so as to provide building materials for the Fabbrica di San Pietro, also ruling that any antique inscription must be submitted to the artist prior to its eventual reuse

in order to gauge its importance for the study of Latin literature and language. In November Raphael is absent from Rome: he may have gone to Florence with Leo X in view of the design for the facade of San Lorenzo, and then to Bologna for the pontiff's meeting with François I. The date 1515, written by Albrecht Dürer, appears on a preparatory drawing for the *Battle of Ostia* [fig. 5 and pl. 39] Raphael gave the German artist and probably on the copy of the portrait of Giuliano de' Medici, duke of Nemours (New York, Metropolitan Museum).

1516

A letter of 30 March from Carlo Agnello from Rome reports to Francesco Gonzaga at Mantua that Raphael has started to portray the elephant Hanno given to the pope in 1514 by the king of Portugal (the painting was doubtless already completed by 25 April; the portrait of Hanno is cited in the epitaph appearing on its tomb in June of the same year). On 4 April Pietro Bembo writes from Rome to Cardinal Bernardo Bibbiena at Fiesole that the next day with Raphael, Andrea Navagero, Agostino Beazzano and Baldassar Castiglione he was to go on an excursion to Tivoli to see "the old and the new, and the beautiful things there are in that county". On 19 April another letter from Bembo mentions the portrait of the Ferrarese poet Antonio Tebaldeo, executed by Raphael, as being even more true to life than the ones of Castiglione [pl. 41] and of Giuliano de' Medici, duke of Nemours. Furthermore, through Bembo, the painter asks that the instructions for the other stories to be painted in Cardinal Bibbiena's *Stufetta* (bathroom) be sent to him (it was completed in June). On 21 June the contract for the *Coronation of Monteluce* is renewed (its first draft dated to eleven years earlier), still in partnership with Berto di Giovanni. A series of letters datable between 15 June and 18 September inform us that Isabella d'Este was able to enter in possession of two gilt silver basins, "antique in make and style", executed at Rome on drawings by Raphael (by a goldsmith who might be Antonio da San Marino or Cesarino da Perugia).

A letter from Leonardo Sellaio from Rome to Michelangelo at Carrara dated 22 November provides the first news of Raphael's activity in sculpture: the execution of a clay model of a putto whose transfer to marble by Pietro d'Ancona (maybe the Pietro Stella documented in Rome in 1519) was almost completed. On 20 December the second known payment for the cartoons for the Sistine tapestries is attested. The date 1516 appears in an inscription on the mosaics of the dome of the Cappella Chigi at Santa Maria del Popolo, along with the signature of the Venetian Luigi de Pace [pl. 36]: "L[udo]v[icus] D[e] P[ace] v[enetus] F[ecit] 1516".

1517

On 19 January Leonardo Sellaio writes to Michelangelo in Florence telling him of the rivalry that had arisen between Raphael and Sebastiano del Piombo over the two paintings commissioned by Cardinal Giulio de' Medici for the cathedral of Narbonne [pl. 48]. An inscription under the *Oath of Leo III* in the Stanza dell'Incendio indicates the fourth year of the pontificate of Leo X (that is, before 19 March 1517: the work in the room would be completed on 25 June). As of March an uninterrupted series of letters between Beltrando Costabili, bishop of Adria and orator for the Este, and Alfonso I, duke of Ferrara, report repeated attempts to convince Raphael to keep to the promise he made several years before to produce an *Indian Triumph of Bacchus* for the 'camerino d'alabastro'.
In September the artist, upon hearing that the duke had Pellegrino da San Daniele execute a work based on the "small format" drawing he had sent to Ferrara [fig. 7], proposed to Alfonso to paint another subject, perhaps the *Hunt of Meleager* mentioned in February 1519 by Girolamo Bagnacavallo: the work was never executed, but to placate the duke Raphael sent him the cartoons of three of his impressive inventions ("a history of pope Leo IV", that is, probably the *Fire in the Borgo* [pl. 38], *Saint Michael Archangel*, and the *Portrait of Isabella d'Aragona*; another cartoon, preparatory for the

Sistine tapestry representing the *Conversion of Saul* is cited in 1521 in the Venetian collection of Cardinal Domenico Grimani). On 30 July Antonio de Beatis, in the travel diary of Cardinal Louis of Aragon, recalls having seen in Brussels, in the workshop of Pieter van Aelst, the tapestries for the Sistine Chapel being woven and apparently completed, the one representing the *Christ's Charge to Peter* being "very handsome". The date 1517 appears in an inscription on the portrait of Valerio Belli (New York, private collection) executed by Raphael (and bearing the inscription "Fatto del'ano 1517 in Rom [...] Rafael Urbinate"): it might be a work given to the great Vicentine goldsmith and etcher to thank him for standing as godfather to an illegitimate daughter of the painter (about whom as yet we have no other information).

1518

In February the portrait of Duke Lorenzo de' Medici, commissioned to Raphael in anticipation of the duke's marriage to Madeleine de la Tour d'Auvergne, was sent to France.
On 1 March a letter from Costabili to Alfonso I mentions the commission of a *St Michael Archangel* for the king of France as one of the reasons for Raphael's delay in the execution of the work for the Este court. On 23 March, in a letter from Baldassare Turini from Rome to Goro Gheri in Florence, another painting for the French court is cited: the *Large Holy Family of François I* (the two works, dated "MDXVIII", were completed in May). In March there is a payment to Raphael for the decoration of the Logge, while on 5 August Luca della Robbia the Younger was paid for the execution of the floor [pl. 43]. A letter from Sebastiano del Piombo to Michelangelo dated 2 July reports that the *Transfiguration* [pl. 48] was not yet begun and that the appearance of the two works for the French court ("they look like figures exposed to smoke, or actually iron figures that shine, all bright and all black") was so ostensibly Leonardesque the Florentine artist would not have liked them at all. In July there is a controversy between the

Curators and Raphael over the ownership of a sculpture (a *Diana* made of several materials and set on a base illustrated with the scene of a sacrifice) from the antique collection of Gabriele de' Rossi who died the year before. In the first days of September the *Portrait of Leo X* is sent to France in view of Duke Lorenzo's wedding with Madeleine: the painting is placed "above the table where the Duchess ate among the other lords and ladies, truly brightening up everything" [pl. 44].

1519
On 1 January Leonardo Sellaio writes to Michelangelo that the vault of the Psyche Loggia at the Farnesina had been unveiled and was a "disgrace for a great master, far worse than the last room in the Palace" [pls. 46 and 38–39]. In February Raphael is engaged on a commission of Cardinal Innocenzo Cibo, the pontiff's nephew, in designing the sets for Ariosto's *I Suppositi* (the comedy would be staged on 6 March). Before 1 March the translation in the vernacular of Vitruvius's *De Architectura* commissioned by Raphael to Fabio Calvo was completed. The Munich manuscript features a series of marginal notes by the artist himself (that prove some proficiency in Latin), while several drawings of the Fossombrone Codex [fig. 8] suggest Raphael was planning a new printed edition, illustrated, of the classical architecture treatise. Another letter dates to before 1 March, written by the artist, inspired by descriptions of the Villas of Cicero and Pliny the Younger, about the design commissioned by Leo X and Cardinal Giulio de' Medici for Villa Madama, celebrated in a short Latin poem by Francesco Sperulo (where Raphael is compared to Apelles). A letter dated 4 May from Marcantonio Michiel from Rome to Antonio Marsilio in Venice reports that Raphael has at the date executed "in the palace four of the Pontiff's rooms" (thus including in the number the Sala dei Palafrenieri, also known as del Pappagallo or dei Chiaroscuri, because of the monochrome frescoes that Raphael's workshop executed before 1517) and "a very long loggia" [pl. 43]. Between May and June an exchange of letters from Federico

Gonzaga in Mantua and Baldassar Castiglione in Rome reports that Raphael had executed a project for the tomb of the deceased *marchese* Francesco. A letter from Marco Minio from Rome informs the Venetian Senate that on 4 July the first three tapestries based on cartoons designed by Raphael [pl. 40] had arrived from Flanders and the artist had suggested raising in Piazza San Pietro an obelisk discovered near the Mausoleum of Augustus (later destined to piazza del Popolo). A passage from the diary of Paride de Grassis remarks the tapestries were exhibited on 26 December in the Sistine Chapel: "de quibus tota cappella stupefacta est in aspectu illorum, qui, ut fuit universale juditium, sunt res qua non est aliquid in orbe nunc pulchrius". The next day Marcantonio Michiel mentions the exhibition of seven tapestries and, speaking of Raphael's Logge, that "the pope placed there a great many statues some secreted in his closet and others purchased beforehand by Pope Julius, perhaps for that purpose". 1519 is also the most likely date for the final drafting of the Letter to Leo X on classical architecture written by Raphael and Baldassar Castiglione that should probably be connected with the graphic reconstruction of classical Rome the pontiff commissioned from the artist.

1520
On 20 March a letter from Rome from Alfonso Paolucci to Alfonso I d'Este at Ferrara reports that Raphael had prepared "three or four" studies of fireplaces for the duke (who in January had bitterly complained about the artist's disrespectful behaviour regarding the painting for the *camerino* promised repeatedly and never consigned). According to the evidence of Marcantonio Michiel's diary, Raphael died in the night between 6 and 7 April, owing to a "continuous high" fever (Alfonso Paolucci): "his death grieved men of letters for his not being able to finish the description and painting of ancient Rome he was working on, and that was a thing of great beauty [...]. He died at 3 o'clock of the night of Holy Friday before Saturday, his birthday". On 7 April the artist was buried in the tomb he had purchased in the Pantheon, having restored an

aedicule of that ancient monument, which ever since his years in Florence, had so deeply influenced the development of his own architectural style. Three days later Agostino Chigi, one of his main patrons, also died.

On 12 April in a letter from Sebastiano del Piombo to Michelangelo where he mentions "poor" Raphael's death, "that I believe must have deeply upset you", the Venetian painter asks him to intercede with Cardinal Giulio de' Medici so that the decoration of the Sala di Costantino be assigned to him, "that Raphael's assistants brag about a great deal and want to paint in oil" (on 6 September he points out they "have the drawings for that room", that is, the master's autograph designs). In May Raphael's pupils working on the Sala di Costantino, that is, Penni and Giulio Romano, offer to execute the painting Alfonso d'Este had so long awaited, but the duke of Ferrara replies that "not having been able to have our picture by his hand, we do not care to have it done in Rome". In June two letters from Cardinal Giulio de' Medici from Florence to Mario Maffei in Rome report the intention to pursue the decoration of the Villa Madama undertaken by Giulio Romano and Giovanni da Udine, "those two madmen", "those two fantastic painters' brains".

CIRCA 1522

The famous letter from the artist to Baldassar Castiglione probably dates to a short while after Raphael's death. Published for the first time by Ludovico Dolce in 1554, it is usually held to be an original text of 1514 by Raphael (sometimes admitting a humanist's stylistic support), yet actually it was in all likelihood produced by the Mantuan writer to "honour the good memory of Raphael, whom I do not love less today than I did when he was alive" (to quote Castiglione's own words in a letter to Cardinal Giulio de' Medici, 7 May 1522). Raphael's excellence as a painter (of the same rank as Leonardo, Mantegna, Michelangelo, and Giorgione) had already been glorified by Castiglione when he wrote, toward 1516, *The Book of the Courtier* (that was to appear in 1528). Now, by this literary fiction that was also

essential through the influence it would have on future art criticism (we need only think of the famous Platonic claim put in the artist's mouth: "[…] I make use of a certain Idea that comes to my mind"), the writer intended to recall the recently deceased artist, drawing a very acute intellectual portrait of him while glorifying himself, emphasising their deep bonds of friendship and collaboration over many years.

ANNOTATED BIBLIOGRAPHY

For obvious reasons, the bibliographical outline that follows is only a fraction of the immense amount of bibliographical material available, which continues to accumulate each year: apart from several crucial contributions of 19th- and 20th-century criticism, the principle applied here was to single out the research of the past twenty years, occasioned by the celebrations of the fifth centennial of Raphael's birth (for the decade that preceded 1983, it is worthwhile consulting *Raphael. A Bibliography 1972–1982*, RILA, International Repertory of the Literature of Art, Williamstown 1984). For finding one's way through the profusion of studies prompted by the 1983 anniversary (the so-called *Anno Santi*, cf. J. Shearman, "Raphael Year: Exhibitions of Paintings and Drawings", *The Burlington Magazine*, CXXVI, 976, 1984, pp. 398–403), the bibliographical survey performed by S. Ferino Pagden for the years 1983–87 is most helpful: "Post Festum. Die Raffaelforschung seit 1983", *Kunstchronik*, XLI, 1988, pp. 194–217.

GUIDELINES

A new starting point for studies on Raphael is the monumental posthumous work by J. Shearman, *Raphael in Early Modern Sources (1483–1602)*, 2 vols. (New Haven-London: 2003), which is more than a simple updating of the praiseworthy but obsolete book by V. Golzio, *Raffaello nei documenti, nelle testimonianze dei contemporanei e nella letteratura del suo secolo* (Vatican City: 1936; 2nd ed., with annotations and corrections by the author, Farnborough: 1971), and not only for the enrichment of the corpus of evidence examined, which has grown from 360 to almost 1,100 documents. Also, in Shearman's book, Raphael's bibliography updated to April 2001 is very useful (cf. vol. II, pp. 1537–635).

On the other hand the new catalogue of Raphael's paintings undertaken by J. Meyer zur Capellen is disappointing: *Raphael. A Critical Catalogue of His Paintings. Volume 1: The Beginnings in Umbria and Florence, ca. 1500–1508* (Landshut: 2001). Regarding the limits of this work, connected with the *Raphael Projekt* promoted by the Universities of Münster and Würzburg, of which for the moment only the first volume has appeared, see the exemplary review by T. Henry, *The Burlington Magazine*, CXLIII, 1182, 2001, pp. 575–76; aside from a number of errors concerning details, the hasty interpretation of the São Paulo *Resurrection of Christ* must be pointed out [pp. 307–8, no. X-8), along with a clamourous mistaken attribution: the re-appraisal of a poor version of the *Holy Family with the Lamb* into an original by Raphael [pp. 191–94, no. 20), to the detriment of the Prado painting, dated 1507.

The latest exhibition devoted to the Urbino artist (*Raffaello. Grazia e bellezza*, exhibition catalogue edited by P. Nitti, C. Restellini, and C. Strinati; Geneva-Milan: 2001) is also by and large a wasted opportunity to sum up twenty years of research that, beginning with the 1983 centennial, profoundly renewed the traditional image of Raphael. An important exhibition on the first period of Raphael's career (*Raphael: from Urbino to Rome*, edited by H. Chapman, T. Henry and C. Plazzotta) is taking place (October 2004) at the National Gallery in London.

A. Ballarin's reflexions on Raphael's career in the early 1520s are extremely relevant, but still accessible only as stencilled university lecture notes: *Pittura del Rinascimento nell'Italia Settentrionale (1480–1540): Venezia 1511–1518: Tiziano dagli affreschi della Scuola del Santo all'Assunta. Raffaello 1511–1514: "a proposito dell'attitudine di Raffaello verso la natura…": la Stanza di Eliodoro, il Ritratto di Giulio II, la Madonna di Foligno, la Madonna Sistina, la Santa Cecilia*, Università degli Studi di Padova, a.a. 1990–91, edited by E. Arregui et al., pp. 54–115. For Raphael's last activity the revision culminating in the large 1999 exhibition in Mantua and then Vienna is fundamental: *Roma e lo stile classico di Raffaello, 1515–1527*, exhibition catalogue edited by K. Oberhuber (Milan: 1999).

PRINCIPAL CATALOGUES AND MONOGRAPHS

L. Pungileoni, *Elogio storico di Raffaello Santi da Urbino* (Urbino: 1829); J. D. Passavant, *Rafael von Urbino und sein Vater Giovanni Santi*, vols. I–II (Leipzig: 1839); vol. III (Leipzig: 1858; Ital. trans. by G. Guasti, 3 vols., Florence: 1882–91); J. A. Crowe and G. B. Cavalcaselle, *Raphael. His Life and Works*, 2 vols., London: 1882–85; Ital. trans. Florence: 1884–91); A. Venturi, *Raffaello* (Rome: 1920); H. Focillon, *Raphaël* (Paris: 1926; 2nd ed. with preface by P. Rosenberg, Paris: 1990); S. Ortolani, *Raffaello* (Bergamo-Milan-Rome: 1942; 2nd ed. edited by C. Gentili, Bologna: 1982); O. Fischel, *Raphael*, edited by B. Rackham, 2 vols. (London: 1948); E. Camesasca, *Tutta la pittura di Raffaello. I quadri* (Milan: 1956); Idem., *Tutta la pittura di Raffaello. Gli affreschi* (Milan: 1956); L. Berti, *Raffaello* (Bergamo: 1961); M. G. Ciardi Dupré, *Raffaello*, 2 vols. (Milan: 1963); P. De Vecchi (ed.), *L'opera completa di Raffaello* (Milan: 1966); L. Dussler, *Raffael. Kritisches Verzeichnis der Gemälde, Wandbilder und Bildteppiche* (Munich: 1966); R. Monti, *Raffaello* (Florence: 1966); *Raffaello: l'opera, le fonti, la fortuna*, edited by M. Salmi, 2 vols. (Novara: 1968; 2nd ed. in one volume, Novara: 1998); J. Pope-Hennessy, *Raphael* (London-New York: 1970; Ital. trans., Turin: 1983); L. Dussler, *Raphael. A Critical Catalogue of His Pictures, Wall-Paintings and Tapestries* (London-New York: 1971); J. H. Beck, *Raphael* (New York: 1976; Ital. trans., Milan: 1982); W. Kelber, *Raphael von Urbino. Leben und Werk* (Stuttgart: 1979); P. De Vecchi, *Raffaello, la pittura* (Florence: 1981); K. Oberhuber, *Raffaello* (Milan: 1982); J.-P. Cuzin, *Raphaël. Vie et œuvre* (Freiburg: 1983); R. Jones and N. Penny, *Raphael* (New Haven-London: 1983); L. D. and H. S. Ettlinger, *Raphael* (Oxford: 1987); S. Ferino Pagden and M. A. Zancan, *Raffaello. Catalogo completo* (Florence: 1989); P. De Vecchi, *Raffaello. La mimesi, l'armonia e l'invenzione* (Florence: 1995); N. Penny, in *The Dictionary of Art*, edited by J. Turner, vol. 25 (London: 1996 [but with a bibliography updated to 1992]), pp. 896–910; J. Meyer zur Capellen, *Raphael in Florence* (London: 1996); K. Oberhuber, *Raffaello: l'opera pittorica* (Milan: 1999); S. Béguin and C. Garofalo, *Raffaello. Catalogo completo dei dipinti* (Santarcangelo di Romagna: 2002); P. De Vecchi, *Raffaello* (Milan: 2002).

PRINCIPAL STUDIES ON RAPHAEL'S DRAWINGS

J. C. Robinson, *A Critical Account of the Drawings by Michel Angelo and Raffaello in the University Galleries, Oxford* (Oxford: 1870); C. Ruland, *The Works of Raphael Santi da Urbino as represented in the Raphael Collection in the Royal Library at Windsor Castle, formed by H. R. H. The Prince Consort, 1853–1861, and completed by Her Majesty Queen Victoria* (London: 1876); O. Fischel, *Raphaels Zeichnungen*, 8 vols. (Berlin: 1913–41); U. Middeldorf, *Raphael's Drawings* (New York: 1945); A. E. Popham and J. Wilde, *The Italian Drawings of the XV and XVI Centuries in the Collection of His Majesty the King at Windsor Castle* (London: 1949); P. Pouncey and A. Gere, *Italian Drawings in the Department of Prints and Drawings in the British Museum: Raphael and his Circle* (London: 1962); K. Oberhuber, *Raphaels Zeichnungen: Abteilung IX. Entwürfe zu Werken Raphaels und seiner Schule im Vatikan 1511–12 bis 1520* (Berlin: 1972); *Disegni umbri del Rinascimento da Perugino a Raffaello*, exhibition catalogue edited by S. Ferino Pagden (Florence: 1982); J. A. Gere and N. Turner, *Drawings by Raphael from the Royal Library, the Ashmolean, the British Museum, Chatsworth and other English collections* (London: 1983); E. Knab, E. Mitsch, and K. Oberhuber, *Raffaello. I disegni*, with the collaboration of S. Ferino Pagden, edited by P. Dal Poggetto (Florence: 1983; original ed. Stuttgart: 1983); P. Joannides, *The Drawings of Raphael, with a Complete Catalogue* (Oxford: 1983); F. Ames-Lewis, *The Draftsman Raphael*, (New Haven-London: 1986); J. A. Gere, *Drawings by Raphael and his Circle. From British and North American Collections* (New York: 1987); G. Passavant, "Publikationen und Ausstellungen von Raffael-Zeichnungen 1983–1986", *Kunstchronik*, XLI, 1988, pp. 217–46; D. Cordellier

and B. Py, *Musée du Louvre. Inventaire général des dessins italiens, V. Raphael, son atelier, ses copistes* (Paris: 1992); the outcome was presented, by the two authors, in a Roman exhibition at the Villa Medici: *Raffaello e i Suoi. Disegni di Raffaello e della sua cerchia*, exhibition catalogue (Rome: 1992); M. Clayton, *Raphael and his Circle. Drawings from Windsor Castle*, exhibition catalogue (London: 1999); *Raphaël et son temps. Dessins du palais des Beaux-Arts de Lille*, exhibition catalogue edited by Joannides (Paris: 2002).

A FEW RECENT ATTRIBUTIONS

F. Todini, "Una Crocifissione del giovane Raffaello a Perugia", *Studi di Storia dell'Arte*, 1, 1990 [but 1991], pp. 113–44 (in which is published a fresco conserved in Perugia, in the old oratory of the Confraternita di Sant'Agostino, that was connected with young Raphael: Todini's suggestion is deemed uncertain, but "interesting", by C. Strinati, "Raffaello", *Art e Dossier*, 97, January 1995, pp. 7 and 50, whereas it is rejected by F. F. Mancini, "Un episodio di normale 'routine': l'affresco cinquecentesco dell'Oratorio di Sant'Agostino a Perugia", *Commentari d'arte*, I, 1995, pp. 29–48): the quality of the most legible details and the comparisons suggested might lead to reconsidering the problem, still been researched, of the activity of Evangelista da Pian di Meleto (see F. F. Mancini, *ad vocem* "Evangelista da Pian di Meleto", in *Dizionario Biografico degli Italiani*, vol. 43, pp. 559–61 [Rome: 1993]), collaborator in the altarpiece of St Nicholas of Tolentino and perhaps also in the *Banner of the Trinity* at Città di Castello.

M. Lucco, "A New Portrait by Raphael and its Historical Context", *Artibus et historiae*, XXI, 41, 2000, pp. 49–73 (that publishes the *Portrait of Costanza Fregoso*, held in a Swiss private collection): the attribution to Raphael in his Florentine years appears convincing, but for the overpainting of the landscape background, attributed by Lucco to a northern Italian painter toward 1515–20 (advancing hypothetically the name of Giovan Francesco Tura), we should not overlook the fact that Battista, Dosso Dossi's brother, is documented with certainty in Raphael's workshop in 1520.

M. Paraventi, "Quel quindicenne potrebbe diventare un Raffaello", *Il giornale dell'arte*, XIX, 196, 2001, p. 51 (in which appears the hypothesis of Grazia Calegari and Maria Rosaria Valazzi, who attribute to Raphael at a very early age, toward 1498, a fresco in the cathedral of Pesaro with a *Madonna and Child with Sts Peter and Jerome* and a *Pietà* in the lunette): the painting seems comparable to the best works by Giovanni Santi. According to P. De Vecchi, *Raffaello*, op. cit., p. 350, no. 37, the frescoes could be attributed to Santi's workshop under the direction of Evangelista da Pian di Meleto.

E. Lunghi, *Una proposta per il giovane Raffaello*, in B. Klein and H. Wolter-von dem Knesebeck (eds.), *Nobilis arte manus, Festschrift zum 70. Geburtstag von Antje Middeldorf Kosegarten* (Dresden-Kassel: 2002), pp. 305–15; Idem, *Raffaello a Cerqueto. Un affresco giovanile e l'esordio in Umbria* (Città di Castello, Perugia: 2003), which publishes the decoration of the Tabernacle of Porta Maltara at Cerqueto: the better conserved parts, and particularly the interesting *all'antica* decoration of the vault, featuring, along with the more customary grotesques, two grisaille imitation antique reliefs with sacrificial scenes, give the impression it might be a product of Pinturicchio's Umbrian circle.

CRITICAL SUCCESS OF RAPHAEL

On the worldwide diffusion of the myth of Raphael, the immense fame his painting enjoyed up until the late 19th century and the reasons of the clear 20th-century disfavour at least until the advent of Postmodernism, see the investigations undertaken on the occasion of the centennial: *Hommage à Raphaël. Raphaël et l'art français*, exhibition catalogue (Paris: 1983); *Raffaello: elementi di un mito. Le fonti, la letteratura artistica,*

la pittura di genere storico, exhibition catalogue (Florence: 1984; cf. especially C. Sisi and E. Spalletti, *Storia e mito di Raffaello nella pittura dell'800 in Italia*, on pp. 161–203). Other cues can be found in the essays in *Raffaello e l'Europa*, proceedings of the IV Corso Internazionale di Alta Cultura, edited by M. Fagiolo and M. L. Madonna, pp. 355–817 (Rome: 1990). In particular for French art up to 1830, see M. L. Rosenberg, *Raphael and France. The Artist as Paradigm and Symbol*, University Park 1995 (cf. also E. Pommier, "Raffaello e il classicismo francese del XVII secolo", *Accademia Raffaello*, 2, 2002, pp. 5–30). A highly interesting episode regarding Raphael's 19th-century success is told, brillantly as always, by F. Haskell, "Un martire dell'attribuzionismo: Morris Moore e l'*Apollo e Marsia* del Louvre (1978)", in *Le metamorfosi del gusto. Studi su arte e pubblico nel XVIII e XIX secolo*, pp. 224–58 (Turin: 1989).

16TH-CENTURY SOURCES

The two editions of Vasari's life of Raphael can be read in G. Vasari, *Le vite de' più eccellenti pittori scultori e architettori nelle redazioni del 1550 e 1568*, text edited by R. Bettarini, secular commentary by P. Barocchi, vol. IV, pp. 155–214 (Florence: 1976); all the other passages from Vasari's *Vite* devoted to Raphael are anthologised in J. Shearman, *Raphael in Early*, op. cit., vol. II, pp. 969–1006 and 1131–96. On Vasari's interpretation of Raphael's works and personality, see L. Becherucci, "Il Vasari e gl'inizi di Raffaello", in *Il Vasari storiografo e artista*, proceedings of the international conference on the fifth centennial of his death (Arezzo-Florence, 2–8 September 1974; Florence: 1976), pp. 179–95; P. De Vecchi, "Raffaello nelle Vite del Vasari", *Arte cristiana*, LXXIII, 709, 1985, pp. 258–62; M. Winner, "Il giudizio di Vasari sulle prime tre stanze di Raffaello in Vaticano", in *Raffaello in Vaticano*, exhibition catalogue edited by F. Mancinelli, pp. 179–93 (Milan: 1984); G. Perini, "'L'ottimo universale' del divino Raffaello: alle radici di una prassi eclettica dell'imitazione",

Accademia Raffaello, 0, 2002, pp. 9–28; G. Vasari, *Das Leben des Raffael*, edited by H. Gründler and V. Lorini (Berlin: 2004). On the use, by Vasari, of prints drawn from Raphael, see J. Wood, "Cannibalized Prints and Early Art History: Vasari, Bellori and Fréart de Chambray on Raphael", *Journal of the Warburg and Courtauld Institutes*, LI, 1988, pp. 210–20. The *Raphaelis Urbinatis Vita* by Paolo Giovio can be read in P. Giovio, *Scritti d'arte. Lessico ed ecfrasi*, edited by S. Maffei, pp. 260–79 (Pisa: 1999) (cf. also J. Shearman, *Raphael in Early*, op. cit., vol. I, pp. 807–12). Other significant excerpts from 16th-century literature on Raphael (Fichard, Dolce) are commented in A. Pinelli, "Raffaello 'convenevole' e Michelangelo 'sconveniente'", in *Studi su Raffaello*, proceedings of the international study seminar, pp. 683–94 (Urbino-Florence, 6–14 April 1984; Urbino: 1987). New poems on Raphael were recently published by G. Perini, "Carmi inediti su Raffaello e sull'arte della prima metà del Cinquecento a Roma e a Ferrara e il mondo dei Coryciana", *Römisches Jahrbuch der Bibliotheca Hertziana*, 32, 1997–98, pp. 367–402.

FOR THE INTRODUCTION

For the introduction quotations, see A. Martini, *Colloqui sulla scultura, 1944–1945, raccolti da G. Scarpa*, edited by N. Stringa, pp. 26 and 210 (Treviso: 1997); R. Guttuso, *Mestiere di pittore. Scritti sull'arte e la società*, pp. 135–36 (Bari: 1972; the essay "Appunti su Raffaello" was published in *Raphael*, 1965, 1, pp. 3–24); A. Chastel, "Raffaello perduto e ritrovato" (1983), in *Raffaello. Il trionfo di Eros*, edited by F. P. Di Teodoro, p. 28 (Vicenza: 1997); original ed., Paris: 1995; R. Longhi, "Ampliamenti nell'Officina ferrarese" (1940), in *Officina ferrarese 1934 seguita dagli Ampliamenti 1940 e dai Nuovi ampliamenti 1940–55*, vol. V, p. 160 (Florence: 1956; the importance of this page is underscored by G. Romano, "Il Cinquecento di Roberto Longhi. Eccentrici, classicismo precoce, maniera" [1982], in *Storie dell'arte. Toesca, Longhi, Wittkower, Previtali*, pp. 50–51 [Rome: 1998]).

ON GIOVANNI SANTI

P. Joannides, "Raphael and Giovanni Santi", in *Studi su Raffaello*, op. cit., pp. 55–61; G. Agosti, "Su Siena nell'Italia artistica del secondo Quattrocento (desiderata scherzi cartoline)", in *Francesco di Giorgio e il Rinascimento a Siena 1450–1500*, exhibition catalogue edited by L. Bellosi, p. 499 (Milan: 1993); R. Varese, *Giovanni Santi* (Fiesole, Florence: 1994); G. Agosti, "Su Mantegna, 4. (A Mantova, nel Cinquecento)", *Prospettiva*, 77, 1995, p. 63; *Giovanni Santi*, proceedings of the international study seminar edited by R. Varese (Urbino, Convento di Santa Chiara, 17–19 March 1995; Milan: 1999).

The *Cronaca rimata* (cf. *Raffaello e la Roma dei Papi*, exhibition catalogue edited by G. Morello, pp. 22–23, no. 8 (Rome: 1986) can be read in the critical edition by L. Michelini Tocci: G. Santi, *La vita e le gesta di Federico di Montefeltro duca di Urbino*, 2 vols. (Vatican City: 1985); the verses of the *Disputa de la Pictura* are anthologised also in C. E. Gilbert, *L'arte del Quattrocento nelle testimonianze coeve*, pp. 118–24 (Florence-Vienna: 1988; original ed., London: 1980). For a possible portrait of Giovanni Santi, executed by Raphael in 1507, see *Raphael, Cellini and a Renaissance Banker. The Patronage of Bindo Altoviti*, exhibition catalogue edited by A. Chong, D. Pegazzano and D. Zikos, pp. 66–67 and 95 (Boston: 2003).

ON THE LIBRETTO DI RAFFAELLO

S. Ferino Pagden, *Gallerie dell'Accademia di Venezia. Disegni umbri* (Milan: 1984; with a suggested attribution in favour of Domenico Alfani); J. Shearman, *Raphael Year*, op. cit., p. 403; *Raffaello e i Suoi*, op. cit., pp. 44–49; *Raphaël et son temps*, op. cit., pp. 92–95, no. 19 (where P. Joannides proposes, as an alternative, the name of Cesarino Rossetti, on the grounds of a passage from the *Elogio degl'huomini illustri di Perugia* by Filippo Alberti [ca. 1575], in which the Perugia goldsmith is referred to as the author of "a book of drawings made in part by one [Raphael] and in part by the other of these two noble spirits").

ON THE ALTARPIECE OF ST NICHOLAS OF TOLENTINO

S. Béguin, "Un nouveau Raphaël au Louvre: un Ange du retable de Saint Nicolas de Tolentino", *La Revue du Louvre et des Musées de France*, XXXI, 1982, pp. 99–115; A. Padoa Rizzo, "Appunti raffaelleschi: l'Incoronazione di San Nicola da Tolentino' per Città di Castello", *Paragone*, XXXIV, 339, 1983, pp. 3–7; S. Béguin, "The Saint Nicholas of Tolentino Altarpiece", in J. H. Beck (ed.), "Raphael before Rome", *Studies in the History of Art*, 17, pp. 15–28 (Washington: 1986); S. Béguin, E. Hall and H. Uhr, "Concerning Raphael's St Nicholas of Tolentino Altarpiece", *The Art Bulletin*, LXIX, 1987, pp. 467–69; E. Mercati, *Andrea Baronci e gli altri committenti tifernati di Raffaello. Con documenti inediti*, Città di Castello 1994, pp. 29–30; A. Forlani Tempesti, "Anteprima per Raffaello: un foglio molto giovanile", in A. Gnann and H. Widauer (eds.), *Festschrift für Konrad Oberhuber*, pp. 34–41 (Milan: 2000); Eadem, in *Da Raffaello a Rossini. La Collezione Antaldi: i disegni ritrovati*, exhibition catalogue edited by A. Forlani Tempesti and G. Calegari, pp. 40–43, no. 16 (Milan: 2001), in which a new preparatory study for the figure of St Nicholas of Tolentino is published; T. Henry, "Raphael's altarpiece patrons in Città di Castello", *The Burlington Magazine*, CXLIV, 1190, 2002, pp. 268–70.

In particular on the Brescian *Angel*, see R. Stradiotti, in *Raffaello a Brescia. Echi e presenze*, exhibition catalogue edited by B. Passamani, pp. 15–17 and 30 (Brescia: 1986). The hypothesis of the provenance of the *Story of St Nicholas of Tolentino* conserved at Pisa (Museo di Palazzo Reale) from the predella of the altarpiece painted by Raphael and Evangelista da Pian di Meleto for Città di Castello has been advanced by Antonino Caleca, whom I wish to thank for discussing with me that fascinating possibility.

ON THE SÃO PAULO KINNAIRD RESURRECTION

After R. Longhi's fundamental interpretation ("Percorso di Raffaello giovine" [1955], in *Cinquecento classico e Cinquecento manieristico*

1951–1970, vol. VIII, pp. 12–13 and 20–21;
Florence: 1976), cf. E. Camesasca, in *Da Raffaello
a Goya… da Van Gogh a Picasso. 50 dipinti dal
Museu de Arte di San Paolo del Brasile*, exhibition
catalogue edited by E. Camesasca, pp. 74–81
(Milan: 1987); J. Barone, "Raffaello al MASP",
Revista de Historia de Arte e Arqueologia, 1, 1994,
pp. 291–98; J. Barone, in L. Marques, *A Arte
Italiana no Museu de Arte de São Paulo*, pp. 56–59
(São Paulo: 1996); J. Barone and L. Marques, in
L. Marques (ed.), *Catalogue of Museu de Arte de
São Paulo: Italian Art*, pp. 64–67 (São Paulo: 1998);
A. Forlani Tempesti, *Anteprima per Raffaello*,
op. cit., pp. 34–41; Eadem, in *Da Raffaello a
Rossini*, op. cit., pp. 40–43, no. 16 (in which a
preparatory study for the figure of the Christ
Risen is published).

ON RAPHAEL'S DRAWINGS DELIVERED
TO PINTURICCHIO FOR THE CYCLE
OF THE PICCOLOMINI LIBRARY

K. Oberhuber, "Raphael and Pintoricchio",
in J. H. Beck (ed.), *Raphael before Rome*, op. cit.,
pp. 155–72; G. V. G. Sheperd, *A monument to Pope
Pius II: Pintorichio and Raphael in the Piccolomini
Library in Siena, 1494–1508*, Phil. Diss., 2 vols.
([1993] University of Harvard, Ann Arbor: 1994).;
S. Röttgen, *Affreschi italiani del Rinascimento.
Tra Quattrocento e Cinquecento*, pp. 296–331
(Modena: 2000; original ed., Munich 1997);
D. Toracca, "Gesta dipinte, gesta narrate.
Appunti a margine della *Partenza di Enea Silvio*
della Libreria Piccolomini", *Annali della Scuola
Normale Superiore di Pisa*, s. IV, Quaderni,
1–2, 1996 [but 1998], pp. 155–60; S. Settis and
D. Toracca (ed.), *La Libreria Piccolomini nel
Duomo di Siena*, Modena 1998, pp. 9, 289–92
and 347–63; G. Sheperd, "Raphael's 'Space-
Composition': From the Piccolomini Library
to the Sistine Tapestries", in L. R. Jones
and L. C. Matthew (eds.), *Coming about…
A Festschrift for John Shearman*, pp. 289–92
(Cambridge, Mass.: 2001); P. Scarpellini
and M. R. Silvestrelli, *Pintoricchio*, pp. 233–41
and 247–72 (Milan: 2003).

ON THE GAVARI (OR MOND) CRUCIFIXION

A. Marabottini, in *Raffaello giovane e Città
di Castello*, exhibition catalogue, pp. 65–67
and 194–95, no. 7 (Città di Castello: 1983);
R. Hiller von Gärtringen, *Raffaels Lernerfahrungen
in der Werkstatt Peruginos. Kartonverwendung
und Motivübernahme im Wandel*, pp. 46–54
(Munich-Berlin: 1999); T. Henry, *Raphael's
altar-piece*, op. cit., pp. 270–4.

ON THE CORONATION OF THE VIRGIN

A. Luchs, "A note on Raphael's Perugian
patrons", *The Burlington Magazine*, CXXV, 958,
1983, pp. 29–31; P. De Vecchi, "The Coronation
of the Virgin in the Vatican Pinacoteca and
Raphael's Activity between 1502 and 1504",
in J. H. Beck (ed.), *Raphael before Rome*,
op. cit., pp. 73–82; F. Mancinelli, *The Coronation
of the Virgin by Raphael*, ivi, pp. 127–36; S. Ferino
Pagden, "Iconographic demands and artistic
achievements: the genesis of three works
by Raphael", in *Raffaello a Roma. Il convegno
del 1983*, pp. 13–19 (Rome: 1986); E.-B. Krems,
Raffaels 'Marienkrönung' im Vatikan (Frankfurt
am Main-Berlin-Bern-New York-Paris-Vienna:
1996); D. Cooper, "Raphael's Altar-Pieces
in S. Francesco al Prato, Perugia: Patronage,
Setting and Function", *The Burlington Magazine*,
CXLIII, 1182, 2001, pp. 554–57.

ON THE MARRIAGE OF THE VIRGIN

C. Bertelli *et al.*, *Lo Sposalizio della Vergine di
Raffaello* (Treviglio: 1983); *Raffaello e Brera*,
exhibition catalogue (Milan: 1984); C. Bertelli,
in *Pinacoteca di Brera. Scuole dell'Italia centrale e
meridionale*, edited by F. Zeri, pp. 192–200, no. 79
(Milan: 1992); P. De Vecchi, *Lo Sposalizio della
Vergine di Raffaello Sanzio* (Milan: 1996);
J. Traeger, *Renaissance und Religion. Die Kunst
des Glaubens im Zeitalter Raphaels*, pp. 44–49,
263–386 and 419–27 (Munich: 1997); T. Henry,
Raphael's altar-piece, op. cit., pp. 274–78.

ON THE VISION OF A KNIGHT

After E. Panofsky's fundamental study, "Hercules am Scheidewege und andere antike Bildstoffe in der neuren Kunst", *Studien der Bibliothek Warburg*, 18 (Leipzig-Berlin: 1930), see also M. E. van Lohuizen-Mulder, *Raphael's Image of Justice – Humanity – Friendship. A Mirror of Princes for Scipione Borghese* (Wassenaar: 1977); C. Gould, "A Note on Raphael and Botticelli", *The Burlington Magazine*, CXX, 909, 1978, p. 841; B.-M. Plemmons, *Raphael 1504–1508*, Phil. Diss., pp. 130–37 and 199–202 (University of California, Los Angeles: 1978); C. Wagner, *Farbe und Metapher. Die Entstehung einer neuzeitlichen Bildmetaphorik in der vorrömischen Malerei Raphaels*, pp. 19–40 (Berlin: 1999); R. Brandt, *Filosofia nella pittura. Da Giorgione a Magritte*, pp. 31–37 (Milan: 2003; original ed., Cologne: 2000).

ON THE THREE GRACES

S. Béguin, "Nouvelles recherches sur le 'Saint Michel' et le 'Saint Georges' du Musée du Louvre", in *Studi su Raffaello*, op. cit., pp. 455–64; E. de Boissard, in *Chantilly, Musée Condé. Peintures de l'Ecole italienne*, pp. 125–27, no. 66 (Paris: 1988); S. Kummer, "Raffael in Umbrien. Die Tafelbilder", in D. Dombrowski (ed.), *Zwischen den Welten. Beiträge zur Kunstgeschichte für Jürg Meyer zur Capellen. Festschrift zum 60. Geburtstag*, pp. 70–73 (Weimar: 2001). In particular on the antique model, see A. M. Riccomini, in S. Settis and D. Toracca (eds.), *La Libreria Piccolomini*, op. cit., pp. 396–402.

ON THE ANSIDEI ALTARPIECE

G. Dalli Regoli, "Raffaello 'angelica farfalla': note sulla struttura e sulle fonti della Pala Ansidei", *Paragone*, XXXIV, 399, 1983, pp. 8–19; F. F. Mancini, *Raffaello in Umbria. Cronologia e committenza. Nuovi studi e documenti*, pp. 57–60 (Perugia: 1987).

ON THE SAN SEVERO TRINITY AND SAINTS

F. Floccia, in *Raffaello giovane*, op. cit., pp. 215–33; F. F. Mancini, *Raffaello in Umbria*, op. cit., pp. 53–56; C. L. Joost-Gaugier, review by J. Meyer zur Capellen, "Raphael. A Critical...", op. cit., *The Sixteenth Century Journal*, XXXIII, 2002, p. 1076.

ON THE PORTRAITS OF THE DONI COUPLE

A. Cecchi, in *Raffaello a Firenze. Dipinti e disegni dalle collezioni fiorentine*, exhibition catalogue, pp. 105–18, nos. 8–9, and pp. 252–55 (Milan: 1984); E. Steingräber, "Anmerkungen zu Raffaels Bildnissen des Ehepaars Doni", in W. Schlink and M. Sperlich (eds.), *Forma et subtilitas. Festschrift für Wolfgang Schoene zum 75. Geburtstag*, pp. 77–88 (Berlin-New York: 1986); A. Cecchi, "Agnolo e Maddalena Doni committenti di Raffaello", in *Studi su Raffaello*, op. cit., pp. 429–39; A. Duelberg, *Privatporträts. Geschichte und Iconologie einer Gattung im 15. und 16. Jahrhundert*, pp. 79–80, 150 and 240, nos. 189–90 (Berlin: 1990); C. Syre, "Raffaels Doni-Porträts für München", in W. Liebenwein and A. Tempestini (eds.), *Gedenkschrift für Richard Harprath*, pp. 451–58 (Munich-Berlin: 1998); D. A. Brown, "Raphael's Portrait of Bindo Altoviti", in *Raphael, Cellini*, op. cit., pp. 97–98. For the question of the author of the mythological scenes on the verso of the two panels (the so-called Maestro di Serumido, according to Luciano Berti and Mina Gregori, that is Aristotile da Sangallo for Federico Zeri), cf. A. Natali, *La piscina di Betsaida. Movimenti nell'arte fiorentina del Cinquecento*, pp. 151–52 (Florence-Siena: 1995), where the proposal to identify the Maestro di Serumido with Ruberto, the son of Filippino Lippi born in 1500, would imply removing the two Ovidian *grisailles* from the corpus of the Florentine eccentric and referring them to an "anonymous early 16th-century painter".

ON THE LADY WITH THE UNICORN

R. Longhi, "Precisioni nelle Gallerie Italiane,
I. R. Galleria Borghese (Precisione aggiunta)",
Vita Artistica, II, 8–9, 1927, pp. 168–73 (reprinted
in Idem, *Precisioni nelle Gallerie italiane. La Regia
Galleria Borghese*, pp. 144–59 [Rome: 1928];
and in *Saggi e ricerche 1925-1928*, vol. II, pp. 320–28
and 350 [Florence: 1967]); C. Bon Valsassina, in
Raffaello nelle Raccolte Borghese, exhibition
catalogue, pp. 20–28 (Rome: 1984); K. Hermann
Fiore, in *Raffaello e Dante*, exhibition catalogue
edited by C. Gizzi, pp. 262–63 (Milan: 1992);
T. Carratù, in *Raffaello. Grazia e bellezza*, op. cit.,
pp. 114–21, no. 9.

ON THE BORGHESE ENTOMBMENT

L. Ferrara, S. Staccioli and A. M. Tantillo, *Storia
e restauro della Deposizione di Raffaello* (Rome:
1972–73); S. Ferino Pagden, *Iconographic demands*,
op. cit., pp. 19–23; M. Rosci, *Raffaello. Deposizione*
(Turin: 1991); H. Locher, *Raffael und das Altarbild
der Renaissance: die "Pala Baglioni" als Kunstwerk
im sakralen Kontext* (Berlin: 1994); N. Spivey,
"Pathos by formula. The Story of Raphael's
Entombment", *Apollo*, 449, 1999, pp. 46–51;
D. Cooper, *Raphael's altar-pieces*, op. cit.,
pp. 557–61; C. Strinati, "La data della Deposizione
Borghese", *Accademia Raffaello*, 1, 2002, pp. 35–42.
For the visual sources, antique and modern, of
Raphael's invention, see S. Settis, "Ars moriendi:
Cristo e Meleagro", *Annali della Scuola Normale
Superiore di Pisa*, s. IV, Quaderni, 1–2 (Pisa: 2000;
Giornate di studio in ricordo di Giovanni Previtali,
edited by F. Caglioti, pp. 145–70 [Siena-Naples-
Pisa: 1998–99]).

ON THE CANIGIANI HOLY FAMILY

H. von Sonnenburg, *Raphael in der Alten
Pinakothek: Geschichte und Wiederherstellung des
ersten Raphael-Gemäldes in Deutschland und der
von König Ludwig I. erworbenen Madonnenbilder*,
exhibition catalogue, pp. 12–89 (Munich: 1983).

ON THE BELLE JARDINIÈRE

S. Béguin, in *Raphaël dans les collections françaises*,
exhibition catalogue, pp. 81–84, no. 6 (Paris: 1983);
J. Shearman, *The Raphael Year*, op. cit., p. 401;
S. Béguin, "Nouvelles analyses résultantes de
l'étude et de la restauration des Raphaël du
Louvre", in *The Princeton Raphael Symposium.
Science in the Service of Art History* (1983),
edited by M. Hall and J. Shearman, pp. 39–47
(Princeton, N.J.: 1990); *Raffaello e i Suoi*, op. cit.,
pp. 96–99.

ON THE MADONNA DEL BALDACCHINO

*Raffello a Pitti. 'La Madonna del baldacchino',
storia e restauro*, exhibition catalogue edited by
M. Chiarini, M. Ciatti and S. Padovani
(Florence: 1991).

FOR THE NEW DOCUMENTS ON RAPHAEL IN
FLORENCE

F. Caglioti, *Donatello e i Medici. Storia del David
e della Giuditta*, vol. I, pp. 336–38 (Florence: 2000);
the cautions of J. Shearman, *Raphael in Early*,
op. cit., vol. I, pp. 118–20, in this case, may be
excessive.

ON SODOMA IN THE STANZA DELLA SEGNATURA

R. Bartalini, *Le occasioni del Sodoma. Dalla Milano
di Leonardo alla Roma di Raffaello*, pp. 113–14
(Rome: 1996); G. Agosti, "Su Mantegna, 6.
(Lombardia)", *Prospettiva*, 85, 1997, p. 72;
R. Bartalini, "Sodoma, the Chigi and the Vatican
Stanze", *The Burlington Magazine*, CXLIII, 1182,
2001, pp. 544–53.

ON THE STANZA DELLA SEGNATURA

J. Beck, *Raffaello. La Stanza della Segnatura* (Turin:
1996; original ed., New York: 1993); B. Kempers,

Ruysch en Erasmus. Een kleine bespiegeling over multidisciplinariteit, internationalisering en kinderen (Amsterdam: 1996); A. Emiliani and M. Scolaro, *Raffaello. La Stanza della Segnatura* (Milan: 2002); C. L. Joost-Gaugier, *Raphael's Stanza della Segnatura. Meaning and Invention* (Cambridge: 2002); V. Farinella, "La Stanza della Segnatura di Giulio II e di Raffaello: una nuova prospettiva", *Res Publica Litterarum*, 26. 2003, pp. 47–79. For Raphael's probable indebtedness to Bramantino, see the truly enlightening page by G. Romano, *Casalesi del Cinquecento. L'avvento del manierismo in una città padana*, p. 42 (Turin: 1970).

In particular on the *Disputation of the Most Holy Sacrament*, see G. Reale, *Raffaello. La "Disputa". Una interpretazione filosofica e teologica dell'affresco con la prima presentazione analitica dei singoli personaggi e dei particolari simbolici e allegorici emblematici* (Milan: 1998); A. Thielemann, *Herrschaftsmetaphorik in Raffaels "Stanza della Segnatura"*, paper read at the conference *Raffaello, pluralità e unità*, Rome, 2–4 May 2002 (forthcoming). In particular on the *School of Athens*, see M. B. Hall (ed.), *Raphael's School of Athens* (Cambridge: 1997); G. Reale, *Raffaello. La "Scuola di Atene". Una nuova interpretazione dell'affresco, con il cartone a fronte* (Milan: 1997); G. W. Most, *Leggere Raffaello. La Scuola d'Atene e il suo pre-testo* (Turin: 2001; original ed., Frankfurt am Main: 1999); for the suggestion to antedate the *School of Athens* to the *Disputation*, going back to Vasari's chronology, see A. Nesselrath, *Raphael's School of Athens* (Vatican City: 1996 [but 1997]). In particular on the *Parnassus*, cf. G. Reale, *Raffaello. Il "Parnaso". Una rilettura ermeneutica dell'affresco con la prima presentazione analitica dei personaggi e dei particolari simbolici* (Milan: 1999); M. Winner, "Lorbeerbäume auf Raffaels Parnass", in M. Seidel (ed.), *L'Europa e l'arte italiana*, pp. 186–209 (Venice: 2000). For the attribution to Lorenzo Lotto of the execution of one of the scenes of the wall of Justice (*Tribonian presents the Pandects to Justinian*), see A. Nesselrath "Lorenzo Lotto in the Stanza della Segnatura", *The Burlington Magazine*, CXLII, 1162, 2000, pp. 4–12.

ON THE PORTRAIT OF JULIUS II

C. Gould, *Raphael's Portrait of Pope Julius II: The Re-emergence of the Original* (London: [1970]); K. Oberhuber, "Raphael and the State Portrait – I. The portrait of Julius II", *The Burlington Magazine*, CXIII, 816, 1971, pp. 124–31; M. Zucker, "Raphael and the Beard of Pope Julius II", *The Art Bulletin*, LIX, 1977, pp. 524–33; L. Partridge and R. Starn, *A Renaissance Likeness. Art and Culture in Raphael's Julius II* (Berkeley-Los Angeles-London: 1980; cf. the review by R. Quednau, "Raphael's *Julius II*", *The Burlington Magazine*, CXXIII, 942, 1981, pp. 551–53); B. Nygren, "Cognitive psychology and the reception of Raphael's Pope Julius II", *Source*, XXI, 2, 2002, pp. 22–29. For Giuliano Della Rovere's figurative interests (cf. recent A. Pastore, *ad vocem* "Giulio II, papa", in *Dizionario Biografico degli Italiani*, vol. 57, pp. 17–26 [Rome: 2001]), before and after the election to the pontificate, cf. at least J. Shearman, "Il mecenatismo di Giulio II e Leone X", in *Arte, committenza ed economia a Roma e nelle corti del Rinascimento (1420–1530)*, proceedings of the international conference, edited by A. Esch and C. L. Frommel (Rome, 24–27 October 1990), pp. 213–42 (Turin: 1995); S. Magister, "Arte e politica: la collezione di antichità del cardinale Giuliano della Rovere nei palazzi ai Santi Apostoli", *Atti della Accademia Nazionale dei Lincei*, CCCIC, 2002, Memorie, s. IX, vol. XIV, fasc. 4, to supplement with F. Caglioti, *Donatello*, op. cit., p. 147; G. Agosti, *Vincenzo Foppa, da vecchio*, in *Vincenzo Foppa*, exhibition catalogue edited by G. Agosti, M. Natale and G. Romano, pp. 51–69 (Milan: 2003).

ON THE VEILED (OR LORETO) MADONNA

La Madone de Lorette (Les dossiers du département des peintures, 19), exhibition catalogue edited by S. Béguin (Paris: 1979); C. Gould, "Afterthoughts on Raphael's so-called Loreto Madonna", *The Burlington Magazine*, CXXII, 926, 1980, pp. 337–41; E. de Boissard, in *Chantilly*, op. cit.,

pp. 130–32, no. 68; G. Santarelli, in *Raffaello e Dante*, op. cit., pp. 81–87.

ON THE PORTRAIT OF TOMMASO INGHIRAMI

D. A. Brown, in *Raphael and America*, exhibition catalogue, pp. 56–59 (Washington: 1983; for the Boston version); G. Chiarini, in *Raffaello a Firenze*, op. cit., pp. 134–43, no. 11; L. Bellosi, "Un omaggio di Raffaello al Verrocchio", in *Studi su Raffaello*, op. cit., pp. 404–5; G. Batistini, "Raphael's portrait of Fedra Inghirami", *The Burlington Magazine*, CXXXVIII, 1121, 1996, pp. 541–45; A. Cecchi, in *L'officina della maniera. Varietà e finezza nell'arte fiorentina del Cinquecento fra le due repubbliche 1494–1530*, exhibition catalogue, p. 130, no. 29 (Venice: 1996). On the personality, known as "Fedra" for his famous interpretation, in 1488, of the role of the protagonist in Seneca's *Hippolyte*, cf. F. Mancinelli, in *Raffaello in Vaticano*, exhibition catalogue, pp. 56–58, no. 36 (Milan: 1984); I. D. Rowland, *The Culture of the High Renaissance. Ancients and Moderns in Sixteenth-Century Rome*, pp. 151–57 and 165 (Cambridge: 1998).

ON THE GALATEA

M. Meiss, "Raphael's Mechanized Seashell: Notes on a Myth, Technology and Iconographic Tradition" (1974), in *The Painter's Choice: Problems in the Interpretation of Renaissance Art*, pp. 203–11 (New York: 1976); C. Thoenes, "Galatea: tentativi di avvicinamento", in *Raffaello a Roma*, op. cit., pp. 59–72; R. Goffen, *Renaissance Rivals. Michelangelo, Leonardo, Raphael, Titian*, pp. 229–35 (New Haven-London: 2002); A. Ballarin (ed.), *Il camerino delle pitture di Alfonso I, Tomo primo. Lo studio dei marmi ed il camerino delle pitture di Alfonso I d'Este, Analisi delle fonti letterarie. Restituzione dei programmi. Riallestimento del camerino*, pp. 241–59 (Cittadella, Padua: 2002); C. L. Frommel (ed.), *La Villa Farnesina a Roma*, pp. 93–99 and 177–78 (Modena: 2003).

ON THE STANZA DI ELIODORO

M. Boskovits, "Raffaello nella Stanza di Eliodoro: problemi (soprattutto) cronologici", *Arte cristiana*, LXXIII, 709, 1985, pp. 222–34; A. Nesselrath, "La stanza di Eliodoro", in *Raffaello nell'appartamento di Giulio II e Leone X*, pp. 203–45 (Milan: 1993); M. Rohlmann, "*Dominus mihi adiutor*. Zu Raffaels Ausmalung der Stanza d'Eliodoro unter den Päpsten Julius II und Leo X", *Zeitschrift für Kunstgeschichte*, LIX, 1996, pp. 1–28. In particular on the *Expulsion of Heliodorus*, cf. J. Shearman, "The Expulsion of Heliodorus", in *Raffaello a Roma*, op. cit., pp. 75–87; M. Schwartz, "Raphael's Authorship in the *Expulsion of Heliodorus*", *The Art Bulletin*, LXXIX, 1997, pp. 467–92. In particular on the *Deliverance of St Peter*, cf. P. De Vecchi, "La liberazione di San Pietro dal carcere", in *Raffaello a Roma*, op. cit., pp. 89–96. On the vault, see S. Ferino Pagden, "Raphael's Heliodorus vault and Michelangelo's Sistine ceiling: an old controversy and a new drawing", *The Burlington Magazine*, CXXXII, 1044, 1990, pp. 195–204.

ON THE PROPHET ISAIAH AND, IN GENERAL,
ON THE ALTAR COMMISSIONED BY GORITZ
IN HONOUR OF ST ANNE

V. A. Bonito, "The St Anne Altar in Sant'Agostino in Rome: A New Discovery", *The Burlington Magazine*, CXXII, 933, 1980, pp. 805–12; Eadem, "The Saint Anne altar in Sant'Agostino: restoration and interpretation", *The Burlington Magazine*, CXXIV, 950, 1982, pp. 268–76; J. F. D'Amico, *Renaissance Humanism in Papal Rome: Humanists and Churchmen on the Eve of the Reformation*, pp. 107–9 (Baltimore-London: 1983); V. A. Bonito and C. Silver, "Some Technical Observations on Raphael's Isaiah and the Accademia San Luca Putto", *Source*, III, 4, 1984, pp. 68–80; B. Montevecchi, "Sant'Agostino", *Le chiese di Roma illustrate*, n.s., 17, pp. 52–58 (Rome: 1985). On Goritz, see recently I. D. Rowland, *The Culture*, op. cit., pp. 189–92 and M. Ceresa, *ad vocem* "Goritz (Küritz), Johann,

detto Coricio", in *Dizionario Biografico degli Italiani*, vol. 58, pp. 69–72 (Rome: 2002).

ON THE FOLIGNO MADONNA

B. W. Lindemann, "'Was soll dieser nackte Knabe da mit seinem Täfelchen?' und andere Probleme der Deutung von Raffaels Madonna di Foligno", *Zeitschrift für Kunstgeschichte*, XLVI, 1983, pp. 307–12; C. Pietrangeli, in *Raffaello in Vaticano*, op. cit., pp. 267–70, no. 97; E. Schröter, "Raffaels Madonna di Foligno. Ein Pestbild?", *Zeitschrift für Kunstgeschichte*, L, 1987, pp. 46–87; R. Schumacher-Wolfgarten, "Raffaels Madonna di Foligno und ihr Stifter. Zu Ikonographie und Auftrag", *Das Münster*, 49, 1996, pp. 15–23; R. J. M. Olson, *The Florentine Tondo*, pp. 39–41 and 266–67 (Oxford: 2000); R. Stefaniak, "Raphael's Madonna di Foligno: Civitas sancta, Hierusalem nova", in *Konsthistorisk tidskrift*, LXIX, 2000, pp. 65–98. For the patron, see R. Ricciardi, *ad vocem* "Conti (de' Conti, de Comitibus, Comes, Comitius)", Sigismondo, in *Dizionario Biografico degli Italiani*, vol. 28, pp. 470–75 (Rome: 1983).

ON THE SISTINE MADONNA

La Madonna per San Sisto di Raffaello e la cultura piacentina della prima metà del Cinquecento, proceedings of the conference edited by P. Ceschi Lavagetto (Piacenza, 10 December 1983; Parma: 1985); A. Prater, "Jenseits und diesseits des Vorhangs. Bemerkungen zu Raffaels 'Sixtinischer Madonna' als religiöses Kunstwerk", *Münchner Jahrbuch der bildenden Kunst*, s. III, XLII, 1991, pp. 117–36; J. Shearman, *Arte e spettatore nel Rinascimento italiano. "Only connect..."* (Milan: 1995; original ed. Princeton, N.J.: 1992), pp. 101–4; D. de Chapeaurouge, *Raffael. Sixtinische Madonna. Begegnung von Caesaren-Papst und Künstler-König* (Frankfurt am Main: 1993); M. Ladwein (ed.), *Raphaels Sixtinische Madonna. Zeugnisse aus zwei Jahrhunderten deutschen Geistesleben* (Stuttgart: 1993); A. Walther,

Die Sixtinische Madonna (Leipzig: 1994); M. Rohlmann, "Raffaels Sixtinische Madonna", *Römisches Jahrbuch der Bibliotheca Hertziana*, XXX, 1995, pp. 221–48; M. V. Schwarz, "Unsichtbares sichtbar. Raffaels Sixtinische Madonna", in *Visuelle Medien im christlichen Kult. Fallstudien aud dem 13. bis 16. Jahrhundert*, pp. 173–215 (Vienna-Cologne-Weimar: 2002). In particular for the motif of the curtain, see J. K. Eberlein, "The Curtain in Raphael's Sistine Madonna", *The Art Bulletin*, LXV, 1983, pp. 61–77.

ON THE VELATA

G. Incerpi, in *Raffaello a Firenze*, op. cit., pp. 174–82, no. 15; P. Barocchi, "Sulla collezione Botti, *Prospettiva*, 93–94, 1999, pp. 126–30; A. Paolucci, in *Raffaello. Grazia e bellezza*, op. cit., pp. 102–5, no. 6; P. Barocchi and G. Gaeta Bertelá, *Collezionismo mediceo e storia artistica*, vol. I, pp. 177–78 (Florence: 2002); S. Padovani, in M. Chiarini and S. Padovani (ed.), *La Galleria Palatina e gli Appartamenti Reali di Palazzo Pitti. Catalogo dei dipinti*, vol. II, p. 324, no. 524 (Florence: 2003).

ON THE MADONNA WITH THE CHAIR

E. H. Gombrich, "La *Madonna della seggiola* di Raffaello" (1955), in *Norma e forma. Studi sull'arte del Rinascimento*, pp. 93–117 (Turin: 1973; original ed. London 1966); G. Incerpi, in *Raffaello a Firenze*, op. cit., pp. 151–65, no. 13; G. Dalli Regoli, *La preveggenza della Vergine. Struttura, stile, iconografia, nelle Madonne del Cinquecento*, pp. 21–22 (Pisa: 1984); Eadem, "'Non... da natura, ma per lo studio': riferimenti, citazioni e rielaborazioni nelle Madonne di Raffaello", in *Studi su Raffaello*, op. cit., pp. 419–28; E. Capretti, in *Magnificenza alla corte dei Medici. Arte a Firenze alla fine del Cinquecento*, exhibition catalogue, p. 184, no. 143 (Milan: 1997); R. J. M. Olson, *The Florentine Tondo*, op. cit., pp. 216–17.

ON THE CHIGI CHAPEL AT SANTA MARIA DEL POPOLO

J. Shearman, *Arte e spettatore*, op. cit., pp. 177–80;
A. Pinelli, "La cappella delle tombe scambiate.
Novità sulla Cappella Chigi in Santa Maria del
Popolo", in *Francesco Salviati et la bella maniera*,
proceedings of the meetings of Rome and Paris
(1998), edited by C. Monbeig Goguel,
P. Costamagna and M. Hochmann, pp. 253–85
(Rome: 2001).

ON THE SAINT CECILIA

A. Emiliani (ed.), *Indagini per un dipinto.
La Santa Cecilia di Raffaello*, Bologna 1983;
*L'Estasi di Santa Cecilia di Raffaello da Urbino
nella Pinacoteca Nazionale di Bologna*, exhibition
catalogue (Bologna: 1983); T. Connolly, *Mourning
into Joy. Music, Raphael, and Saint Cecilia*
(New Haven-London: 1994); F. P. Di Teodoro,
"…'e similmente alcuni suoi veli e vestimenti
di drappi d'oro e di seta'…: nota sulla Santa
Cecilia di Raffaello", in W. Liebenwein and
A. Tempestini (eds.), *Gedenkschrift*, op. cit.,
pp. 131–16; A. Rizzi, "Sulla Santa Cecilia di
Raffaello a Bologna", in *Scritti di storia dell'arte
in onore di Jürgen Winckelmann*, Naples 1999,
pp. 287–95. For the presumed intervention
of Giovanni da Udine, see N. Dacos and
C. Furlan, *Giovanni da Udine 1487–1561*, pp. 14–18
(Udine: 1987). It is worthwhile also mentioning
the essay by M. Ferretti on the frame, a work
by the Sienese carver Giovanni Barili: "'Con
l'ornamento, come l'aveva esso acconciato'.
Raffaello e la cornice della 'Santa Cecilia'",
Prospettiva, 46, 1985, pp. 12–25.

FOR RAPHAEL'S ACTIVITY IN THE FIELD
OF ARCHITECTURE (a theme barely touched
upon in this synthetic reconsideration
of his pictorial work)

S. Ray, *Raffaello architetto*, Bari 1974;
C. L. Frommel, S. Ray and M. Tafuri, *Raffaello
Architetto* (Milan: 1984, 2nd ed.; the section

Raffaello e l'antico was edited by H. Burns and
A. Nesselrath); cf. as well H. Biermann, "Raffaello
architetto", *Kunstchronik*, XLI, 1988, pp. 247–60.

ON THE STANZA DELL'INCENDIO

R. Quednau, "Päpstliches Geschichtsdenken und
seine Verbildlichung in der Stanza dell'Incendio",
in *Münchner Jahrbuch der bildenden Kunst*, XXXV,
1984, pp. 83–128; J. W. Jacoby, *Den Päpsten zu
Diensten. Raffaels Herrscherzyklus in der Stanza
dell'Incendio in vatikanischen Palast* (Hildesheim-
Zurich-New York: 1987); A. Nesselrath,
"Art-historical Findings during the Restoration of
the Stanza dell'Incendio", *Master Drawings*, XXX,
1992, pp. 31–60; F. Mancinelli and A. Nesselrath,
"La Stanza dell'Incendio", in *Raffaello
nell'appartamento*, op. cit., pp. 293–337; A. Gnann,
in *Roma e lo stile classico*, op. cit., pp. 60–66;
P. Joannides, "Giulio Romano in Raphael's
Workshop", *Quaderni di Palazzo Tè*, 8, 2000,
pp. 42–45; M. Rohlmann, "Gemalte Prophetie.
Papstpolitik und Familienpropaganda im
Bildsystem von Raffaels 'Stanza dell'Incendio'",
in G.-R. Tewes and M. Rohlmann (eds.),
*Der Medici-Papst Leo X. und Frankreich. Politik,
Kultur und Familiengeschäftes in der europäischen
Renaissance*, pp. 241–333 (Tubingen: 2002);
B. Kempers, "'Sans fiction ne dissimulation'.
The crowns and crusaders in the Stanza
dell'Incendio", in *Der Medici-Papst Leo X. und
Frankreich*, op. cit., pp. 373–415.

ON THE CARTOONS OF THE
SISTINE CHAPEL TAPESTRIES

J. Shearman, *Raphael's Cartoons in the Collection
of Her Majesty the Queen and the Tapestries for the
Sistine Chapel*, London 1972; C. Gilbert, "Are the
Ten Tapestries a Complete Series or a Fragment?",
in *Studi su Raffaello*, op. cit., pp. 533–50; S. Fermor,
*The Raphael Tapestry Cartoons. Narrative.
Decoration. Design* (London: 1996); R. Harprath,
Scritti su Raffaello, edited by F. P. Di Teodoro and
A. Tempestini, pp. 33–43, 55–59 and 131–48

(Urbino: 1997); S. Fermor and A. Derbyshire, "The Raphael Tapestry Cartoons Re-examined", *The Burlington Magazine*, CXL, 1141, 1998, pp. 236–50; T. Weddingen, "Tapisseriekunst unter Leo X. Raffaels Apostelgeschichte für die Sixtinische Kapelle", in *Hochrenaissance im Vatikan (1503–1534). Kunst und Kultur im Rom der Päpste I.*, exhibition catalogue, pp. 268–84 (Bonn: 1999); M. Clayton, *Raphael and his Circle*, op. cit., pp. 99–113; G. Sheperd, *Raphael's "Space-Composition"*, op. cit., pp. 292–96.

ON MARCANTONIO RAIMONDI'S QUOS EGO

L. Nees, "Le Quos Ego de Marc-Antoine Raimondi", *Nouvelles de l'estampe*, 40–41, 1978, pp. 18–24; C. Lord, "Raphael, Marcantonio Raimondi, and Virgil", *Source*, III, 4, 1984, pp. 81–92; *Roma e lo stile classico*, op. cit., pp. 114–15, no. 53.

ON THE PORTRAIT OF BALDASSAR CASTIGLIONE

J. Shearman, "Il ritratto di Baldassare Castiglione" (1979), in A. Nova (ed.), *Funzione e illusione. Raffaello Pontormo Correggio*, pp. 99–113 (Milan: 1983); Idem, *Arte e spettatore*, op. cit., pp. 134–37; P. De Vecchi, in *Raffaello. Grazia e bellezza*, op. cit., pp. 106–9, no. 7. For the letter to Leo X, see recently F. P. Di Teodoro, *Raffaello, Baldassar Castiglione e la Lettera a Leone X con l'aggiunta di due saggi raffaelleschi* (Bologna: 2003; 1st ed. Bologna: 1994).

ON THE SPASIMO DI SICILIA
OR CHRIST FALLS ON THE WAY TO CALVARY

A. Nesselrath, in *Raffaello in Vaticano*, op. cit., p. 283, no. 106; *Raphael en España*, exhibition catalogue, pp. 14–18, 121–23 and 139, no. 4 (Madrid: 1985); M. A. Spadaro, *Raffaello e lo Spasimo di Sicilia* (Palermo: 1991); *Roma e lo stile classico*, op. cit., pp. 86–87, nos. 26–27; C. G. d'Alibrando, *Il Spasmo di Maria Vergine.*

Ottave per un dipinto di Polidoro da Caravaggio a Messina, edited by B. Agosti, G. Alfano, and I. di Majo, pp. XV, XXVII, XLIII, 8, 43 and 53 (Naples: 1999); E.-B. Krems, *Raffaels römische Altarbilder: Kontext, Ikonographie, Erzählkonzept. Die Madonna del Pesce und Lo Spasimo di Sicilia*, pp. 173–273 (Munich: 2002).

ON THE VATICAN LOGGE

B. F. Davidson, *Raphael's Bible. A Study of the Vatican Logge* (New York: 1985); N. Dacos, *Le Logge di Raffaello. Maestro e bottega di fronte all'antico* (2nd ed. updated, Rome: 1986; 1st ed. Rome: 1977); C. Denker Nesselrath, "La Loggia di Raffaello", in *Raffaello nell'appartamento*, op. cit., pp. 39–79; *Roma e lo stile classico*, op. cit., pp. 21–22 and 156–79.

ON THE TRIUMPH OF BACCHUS IN INDIA

J. Shearman, "Alfonso d'Este's Camerino", in *"Il se rendit en Italie". Etudes offertes à André Chastel*, pp. 209–30 (Rome-Paris: 1987); A. Ballarin (ed.), *Il camerino delle pitture*, op. cit., pp. 206–17, 328–39, 388–89 and 418–37.

ON THE RECONSTRUCTION OF ANCIENT ROME
AND FOR THE FOSSOMBRONE CODEX

A. Nesselrath, "Raphael's Archaeological Method", in *Raffaello a Roma*, op. cit., pp. 357–71; Idem, *Das Fossombroner Skizzenbuch* (London: 1993); G. Perini, "Raffaello e l'antico: alcune precisazioni", *Bollettino d'Arte*, LXXXIX-XC, 1995, pp. 111–14.

ON THE PORTRAIT OF LEO X

R. Sherr, "A New Document Concerning Raphael's Portrait of Leo X", *The Burlington Magazine*, CXXV, 958, 1983, pp. 31–32; E. Allegri, in *Raffaello a Firenze*, op. cit., pp. 189–98, no. 17;

J. Shearman, *Arte e spettatore*, op. cit., pp. 127–29; A. Natali, in *L'officina della maniera*, op. cit., pp. 194–95, no. 57; *Raffaello e il ritratto di papa Leone. Per il restauro del Leone X con due cardinali nella Galleria degli Uffizi* (Cinisello Balsamo, Milan: 1996); F. P. Di Teodoro, *Ritratto di Leone X di Raffaello Sanzio* (Milan: 1998).

ON THE LOUVRE DOUBLE PORTRAIT

J. Shearman, in *Raffaello Architetto*, op. cit., p. 107; N. Gramaccini, "Raffael und sein Schule – eine gemalte Kunsttheorie", *Georges-Bloch-Jahrbuch des Kunstgeschichtlichen Seminars der Universität Zürich*, 2, 1995, pp. 44–55; H. Baader, "Sehen, Tauschen und Erkennen. Raffaels Selbstbildnis aus dem Louvre", in C. Goettler (ed.), *Diletto e maraviglia. Ausdruck und Wirkung in der Kunst von der Renaissance bis zum Barock (Rudolf Preimesberger zum 60. Geburtstag)*, pp. 40–59 (Emsdetten: 1998); P. Joannides, *Giulio Romano*, op. cit., pp. 34–42; T. Carratù, in *Raffaello. Grazia e bellezza*, op. cit., pp. 110–3, no. 8; R. Zapperi, "Raffaels Bildnis Papst Leos X. Mit zwei kardinales", in B. Hüttel, R. Hüttel and J. Kohl (eds.), *Re-Visionen. Zur Aktualität von Kunstgeschichte*, pp. 97–105 (Berlin: 2002).

ON THE LOGGIA OF PSYCHE

Dal testo all'immagine: Amore e Psiche nell'arte del Rinascimento, proceedings of the conference edited by S. Cavicchioli, *Fontes*, III, 5–6, 2000; H. Günther, "Amor und Psyche. Raffaels Freskenzyklus in der Gartenloggia der Villa des Agostino Chigi und die Fabel von Amor und Psyche in der Malerei der italienischen Renaissance", *Artibus et historiae*, XXII, 44, 2001, pp. 149–66; S. Cavicchioli, *Le metamorfosi di Psiche. L'iconografia della favola di Apuleio*, pp. 68–83 (Venice: 2002); R. Varoli-Piazza (ed.), *Raffaello. La loggia di Amore e Psiche alla Farnesina* (Cinisello Balsamo, Milan: 2002); M. Rohlmann, "Von allen Seiten gleich nackt Raffaels Kompositionskunst in der Loggia di Psiche der

Villa Farnesina", *Wallraf-Richartz-Jahrbuch*, 63, 2002, pp. 71–92; C. L. Frommel (ed.), *La Villa Farnesina*, op. cit., pp. 99–121 and 169–75.

ON THE VISION OF EZEKIEL

L. Monaci Moran, in *Raffaello a Firenze*, op. cit., pp. 199–206, no. 18; A. Natali, "Pinacoteca fiorentina. Percorso indiziario per la 'visione di Ezechiele' di Raffaello", *Artista*, 1, 1989, pp. 78–85; S. Padovani, in M. Chiarini and S. Padovani (eds.), *La Galleria Palatina*, op. cit., p. 322, no. 521.

ON THE TRANSFIGURATION

F. Mancinelli, *La Trasfigurazione di Raffaello: primo piano di un capolavoro* (Vatican City: [1979]), with some extraordinary life-size photographic details; S. Freedberg, F. Mancinelli, and K. Oberhuber, *A Masterpiece Close-up: the Transfiguration by Raphael*, exhibition catalogue, Cambridge, Mass., 1981; E. H. Gombrich, "The Ecclesiastical Significance of Raphael's Transfiguration", in J. A. Chroscicki (ed.), *Ars auro prior: studia Ioanni Bialostocki sexagenario dicata*, pp. 241–43 (Warsaw: 1981); K. Oberhuber, *Raphaels 'Transfiguration'. Stil und Bedeutung* (Stuttgart: 1982); C. King, "The Liturgical and Commemorative Allusions in Raphael's Transfiguration and Failure to Heal", *Journal of the Warburg and Courtauld Institutes*, XLV, 1982, pp. 148–59; C. Gardner Teuffel, "Sebastiano del Piombo, Raphael and Narbonne", *The Burlington Magazine*, CXXVI, 981, 1984, pp. 765–66 (for the discovery of a piece of Giovanni Barili's original frame); D. A. Brown, "Leonardo and Raphael's Transfiguration", in *Raffaello a Roma*, op. cit., pp. 237–43; S. Ferino Pagden, *Iconographic demands*, op. cit., pp. 24–27; R. Preimesberger, "Tragische Motive in Raffaels 'Transfiguration'", *Zeitschrift für Kunstgeschichte*, 50, 1987, pp. 88–115; S. Schröer-Trambowsky, "Das Vermächtnis von Raphaels Transfiguration: Heilungswirkung durch Malerei, in A. Gnann and H. Widauer (eds.), *Festschrift für Konrad*

Fig. 9. Pierre Puvis de Chavannes, *The Sacred Wood Dear to the Arts and Muses*,
Lyon, stairway of the Musée des Beaux-Arts.

Oberhuber, op. cit., pp. 43–55; L. C. Agoston,
"Transfiguring Raphael: Identity, Authenticity and
the Person of Christ", in L. R. Jones and L. C.
Matthew (eds.), *Coming about*, op. cit., pp. 115–22;
P. De Vecchi, *Raffaello. La Trasfigurazione* (Cinisello
Balsamo, Milan: 2003); J. Granston, "Tropes of
Revelation in Raphael's Transfiguration",
Renaissance Quarterly, LVI, 2003, pp. 1–25.

FOR THE ENVOY

For a discussion on the painting by Puvis de
Chavannes [fig. 9], see P. Vaisse, "Puvis de
Chavannes et l'escalier du musée des Beaux-Arts
de Lyon", in *Puvis de Chavannes au musée des
Beaux-Arts de Lyon*, exhibition catalogue edited
by D. Brachlianoff, p. 24–53 (Paris: 1998); for the
Costabili letter, see A. Ballarin (ed.), *Il camerino
delle pitture*, op. cit., p. 421; for Derain's
judgement, see C. Derouet, in *Les Réalismes*,
exhibition catalogue edited by P. Hulten, p. 208
(Paris 1980; the essay "Sur Raphaël" appeared in
L'Ésprit nouveau, 3 December 1920).

FOR RAPHAEL'S BIOGRAPHY

The biography of Raphael is based (with a few
minor additions) on the sources and documents
assembled and re-examined in J. Shearman,
Raphael in Early Modern Sources, 1483-1602 op. cit.;
in particular on the much discussed 1514 letter to
"Signor Conte", see Idem, "Castiglione's Portrait
of Raphael", *Mitteilungen des Kunsthistorischen
Institutes in Florenz*, XXXVIII, 1994, pp. 69–97.

[4] Vincenzo Farinella teaches History of Modern Art at the University of Pisa. He studied Italian Renaissance art in its relationship with classical Antiquity, writing a number of articles and essays on the subject (including the book *Archeologia e pittura a Roma tra Quattrocento e Cinquecento. Il caso di Jacopo Ripanda*, Turin 1992). He also dealt with the affinities between Italian and European figurative art at the turn of the nineteenth century (mounting the exhibition *Pittura dei campi. Egisto Ferroni e il Naturalismo europeo*, Livorno 2002).